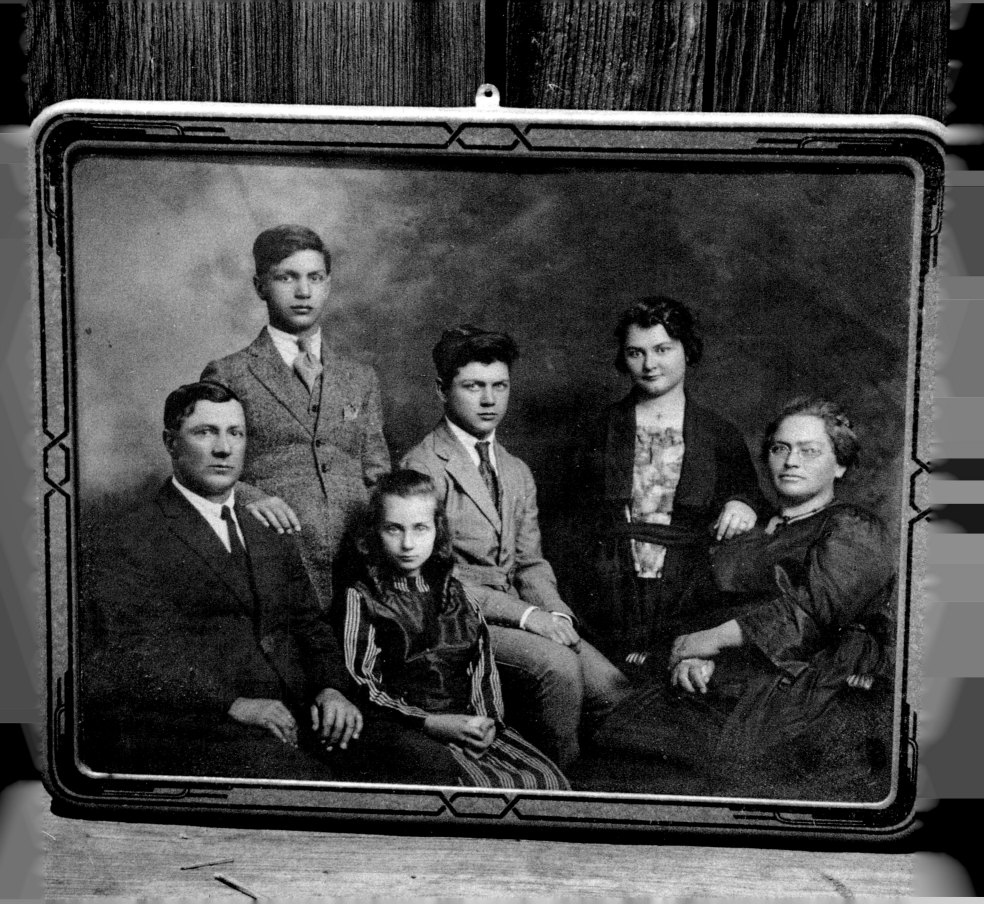

ACKNOWLEDGMENTS

There are literally hundreds of people who have contributed in one way or another to *Dust Bowl Descent* and to whom I extend my gratitude.

The list must begin with the photographers of the Farm Security Administration (FSA) for creating the file and the curators at the Library of Congress Prints and Photographs Division for maintaining it. Several of the FSA photographers gave generously of their time and memories, particularly Arthur Rothstein, along with Russell Lee, Jack Delano, and Marion Post Wolcott. At the Library of Congress, the help of staff members Leroy Bellamy, Sam Daniel, Jerry Kearns, Gerry Maddox, and Alan Fern was invaluable.

Other research sources and books allowed insights into the history of the FSA and the photographers I did not meet (including Roy Stryker, who died shortly after I began a correspondence with him). F. Jack Hurley's book *Portrait of a Decade* (Baton Rouge: Louisiana State University Press, 1972) has justifiably become the standard history of the FSA and I owe Hurley a great debt. *An American Exodus,* by Dorothea Lange and Paul Schuster Taylor (1939; reissued in 1969 for the Oakland Museum by Yale University Press), powerfully portrays the lives of the Okies, effectively presents Lange's work, and taught me something of what a book of words and pictures can accomplish. J. Russell Smith's 1925 edition of *North America* (New York: Harcourt, Brace and Company) was a standard reference book for the FSA photographers and gave me some sense of the economic and social contexts they were operating within. *California and the Dust Bowl Migration,* by Walter J. Stein (Westport, Conn.: Greenwood Press, 1973), provided a more quantitative look at the Okies; and Milton Meltzer gives us an excellent biography of the woman who photographed them in *Dorothea Lange: A Photographer's Life* (New York: Farrar, Straus and Giroux, 1978). There are also several good collections of FSA photographs, including: *A Vision Shared,* edited by Hank O'Neal (New York: St. Martin's Press, 1976); *In This Proud Land,* by Roy Emerson Stryker and Nancy Wood (Greenwich: New York Graphic Society, 1973); *The Depression Years,* by Arthur Rothstein (New York: Dover Publications, 1978); *Russell Lee: Photographer,* by F. Jack Hurley (Dobbs Ferry, N.Y.: Morgan and Morgan, 1979); and *Celebrating a Collection: The Work of Dorothea Lange,* by Therese Thau Heyman (Oakland, Calif.: Oakland Museum, 1978).

The Oakland Museum also opened its collection and allowed me to go through Lange's original field notes. Steve Plattner generously reproduced some of his research material and acted as an excellent sounding board for my ideas. And the University of Louisville Photographic Archive supplied microfilm of Stryker's correspondence and shooting scripts.

When I began this project it quickly became apparent that I would need outside funding to complete it. Over the years several individuals and organizations have provided that support. The Nebraska Educational Television Council for Higher Education (NETCHE) provided early support and allowed me to make the initial extended trips on the project. Loans from an understanding Lancaster County Bank supported the next phase of the project and my thanks go particularly to Dennis Seawell. Finally, in 1979, a grant from the Nebraska Committee for the Humanities (NCH) supported a year of field work and the construction of a traveling exhibition, and I want to single out NCH staff members Mike Holland and Ann Cognard for their help. The sponsors of that grant request were the Center for Great Plains Studies at the University of Nebraska–Lincoln and the Nebraska State Historical Society; my gratitude goes to Paul Olson and Brian Blouet of the Center and Marvin Kivett of the Society for committing their organizations to the project. Additional funding came from private sources, including the Woods Charitable Fund, Banker's Life Nebraska, the Cooper Foundation, Lincoln Equipment Company, the Omaha National Bank, the Phillips Petroleum Foundation, the J. C. Seacrest Trust, and Valmont Industries. The exhibit which came out of that year is still touring under the auspices of the Mid-America Arts Alliance of Kansas City, and Edeen Martin was invaluable in arranging the tour.

Friends and family who put up with me and offered encouragement deserve all the gratitude I can give: my wife, Mary Ethel Emanuel, who often provided more than emotional support; my father and mother, Dwight and Margaret Ganzel; John Carter of the Nebraska State Historical Society, without whose optimistic support the project would not have come about; Roger Welsch, Jim Potter, and Keith Jacobshagen, who served as content consultants for the NCH grant; and Douglass Scott, who designed the exhibit and kept me going. There is also a remarkable community of photographers and friends around Lincoln who were continual sounding boards for ideas: Roger Bruhn, David Murphy, Larry Ferguson, Margaret MacKichan, John Spence, Bob Robinson, and former teachers George Tuck and Jim Alinder.

Finally, my thanks have to go to all of the people in this book who opened their lives to me. Without them this book would not exist.

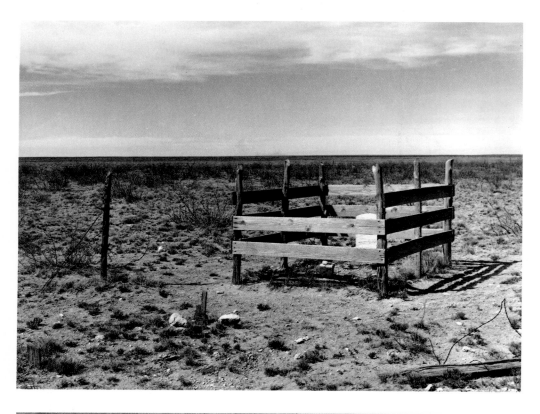

1
Grave on the
high plains
Dawson County,
Texas
March 1940
Russell Lee

2
Graveyard at the
rural Community
Presbyterian Church
Near Pleasant Dale,
Colorado
October 1979

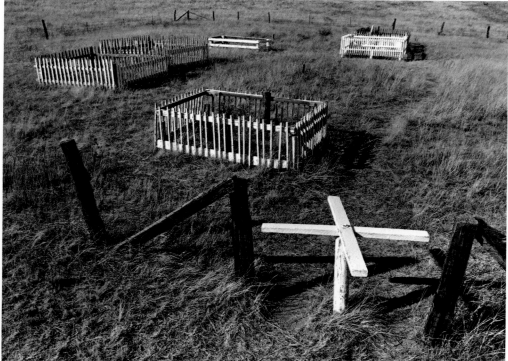

INTRODUCTION

When I was growing up, there was a ritual that my father performed every year. On the first day of school he would line us kids up in our new clothes and take a photograph. Over the years, those photographs became a serial document of our growth. Occasionally, we would bring them out of the shoe box where they were collected, and we would pass them around. We would marvel at how much we had grown from one photograph to the next, or how much clothes and hair styles had changed. And we would recognize and remember the embarrassment and anticipation that showed in our faces—embarrassment at having to stand there for the ritual, anticipation of the new year. If, as I suspect, the ritual was performed in other families as well (certainly my grandfather took photographs of my father as he was growing up during the Depression), in that collective mound of processed silver images there would be a wealth of information going beyond the original purposes of the photographs.

In a way, this book is like that ritual, but with a different purpose and scope. I have tried to show what life in a particular region of the United States—the Great Plains—has been like, using photographs taken during two distinct periods of time. The starting point for this portrait is the remarkable collection of 80,000 photographs made during the Depression of the 1930s by the gifted photographers of the Farm Security Administration (FSA), a New Deal agency of the U.S. government. For nine years, from 1935 to 1943, the FSA photographers crisscrossed the country; they produced a visual record of the time that remains unique in its breadth and quality. Using FSA photographs, I tracked down some of the same people, places, and situations on the Great Plains about forty years later. I photographed them, and I interviewed many of the people in the photographs to find out what had happened to them over the years.

Dust Bowl Descent, like the pictures my father made on the first day of school, is a collection of photographs of the same subjects taken over a period of time. However, there are differences between my father's and my photographs that get to the heart of my intentions. In my father's photographs, the visual elements changed very little—only when a new member of the family reached school age or when we moved to a new community. He always lined us up by the back door and took the photograph straight on from about the same distance. With a different goal in mind, I have not set out to reproduce exactly the visual elements of the FSA photographs, either in pose, camera angle, point of view, technique, focal length, or composition. In a few instances I have even photographed a different, although similar, subject. My photographs are closely related to those of the FSA, but they are not replicas.

I chose not to replicate the FSA photographs because I was interested in more than just change, more than just how surface appearances alter over time. This book is a portrait, first, of the Great Plains as a unique environment that has molded the people who live there; only secondarily is it a portrait of the plains over the last five decades.

My goal has been for each photograph in the book to document accurately its subject, wherever and whenever the subject was photographed. Thus, a pair of photographs taken at different times and in different parts of the plains can document a similar response to the environment: the grave on the high plains of Texas in 1940, for example, and the graveyard in Colorado in 1979 were both fenced to protect the sites and to make a mark on the flat landscape.

My concern in reproducing these photographs as pairs is not simply with an apparent lack of change. Rather, the plains landscape has affected, in one way or another, the people who

have lived on it, and I, like FSA photographer Russell Lee, have tried to convey that.

There are other things, of course, that have changed dramatically over the last forty years, and I have tried to show these changes by finding and photographing their contemporary counterparts. My concern here was with those factors that made the Depression and the late 1970s unique. For instance, there were some photographs in the FSA collection that had no contemporary counterparts, that could only have been made in the 1930s; there were times when I hoped a dust storm would blow up so that I could produce photographs like the remarkable image at the right.

Dust still blows on the plains, but day after day of choking dust, turning noon into night, has not been seen since the 1930s. The Dust Bowl produced its worst storms in the southern plains—in southwest Kansas, southeast Colorado, and the panhandles of Oklahoma and Texas—but dust blew throughout the plains region, and dust from the plains darkened the horizon all the way to the east coast of the United States.

The Dust Bowl was unique to the Great Plains, but the fundamental fact of the 1930s was the Great Depression. The Depression was a national disaster, but among the states hardest hit were those on the plains—Texas, Oklahoma, Kansas, Nebraska, North and South Dakota, Montana, Colorado, Wyoming, and New Mexico. The severe and prolonged drought that brought the dust further crippled the region's already ailing principal industry, agriculture, leaving the economy of the plains particularly depressed. In 1933, the average per capita income in North Dakota was $145 a year, compared with a national average of $375. A high proportion of plains farm families were forced

to accept relief, despite their traditional abhorrence of such "charity." In June 1935, while 18 percent of the urban families in the nation were on some form of relief, 36 percent of the farm families in New Mexico were on relief. South Dakota had the next highest percentage with 33 percent of its farm families on relief, then North Dakota and Oklahoma each with 27 percent, and Colorado with 20 percent. Five of the ten Great Plains states led the nation in the proportion of farm families on relief.[1]

The Depression hastened a massive shift in population from rural areas to urban. The Dust Bowl of the southern plains lost one-third of its population during the decade, mostly to California. This movement did not begin in the thirties, but the exodus of whole families from rural areas became epidemic during the decade, and that exodus has continued. From the Dust Bowl, to the Okies and *The Grapes of Wrath,* to the explosion of hoboes riding the rails, the plains provided the central images of the Depression—memories (for those who lived through it) and symbols (for those who did not) of what happens when everything goes wrong.

Not only the memory of the Depression, but also the government programs implemented to alleviate it have left a legacy affecting American life today. The New Deal, President Franklin D. Roosevelt's response to the Depression, created agencies and programs that remain basic to American policy in agriculture, social welfare, labor relations, banking, and management of the economy.

High among FDR's priorities was the Agricultural Adjustment Act (AAA). Rexford Tugwell, one of the original "brain trusters," whom Roosevelt had appointed assistant secretary of agriculture, helped to write the sweeping reforms embodied in the AAA. The act, which

passed Congress during the first one hundred days of Roosevelt's administration, established a system of government price supports for agricultural commodities, tied to reductions in crop production.

But the act had a few holes, through which millions of tenant farmers started falling. The AAA paid landowners to hold crops off the market without taking into account the landowners' tenants. Landowners across the nation quickly realized they could take their government payments, buy the tractor they had been wanting, and get rid of their tenants.[2] One man with a tractor could farm the land much more cheaply than several tenant families using horses or mules. The tenants were "tractored out," forced off the land their families may have farmed for generations but never owned. They had nowhere to go but to join the stream of migrants looking for work. Those who did stay most often lived in debilitating poverty, part of the "one-third of a nation . . . ill-fed, ill-clad, and ill-housed" that FDR identified and set out to help.

To assist these people, FDR created the Resettlement Administration, in April 1935, by executive order, naming Tugwell as its director. The agency's primary programs included loans to tenant farmers to allow them to buy land, conservation and reclamation of farmland, and a hodgepodge of innovative and controversial attempts to resettle displaced farmers. When Roosevelt's executive order was later declared unconstitutional, most of these programs were transferred to a new agency, the Farm Security Administration.

Tugwell realized that, to perform its tasks in the face of conservative political criticism, the agency would have to rally public support for its programs. That would be difficult because

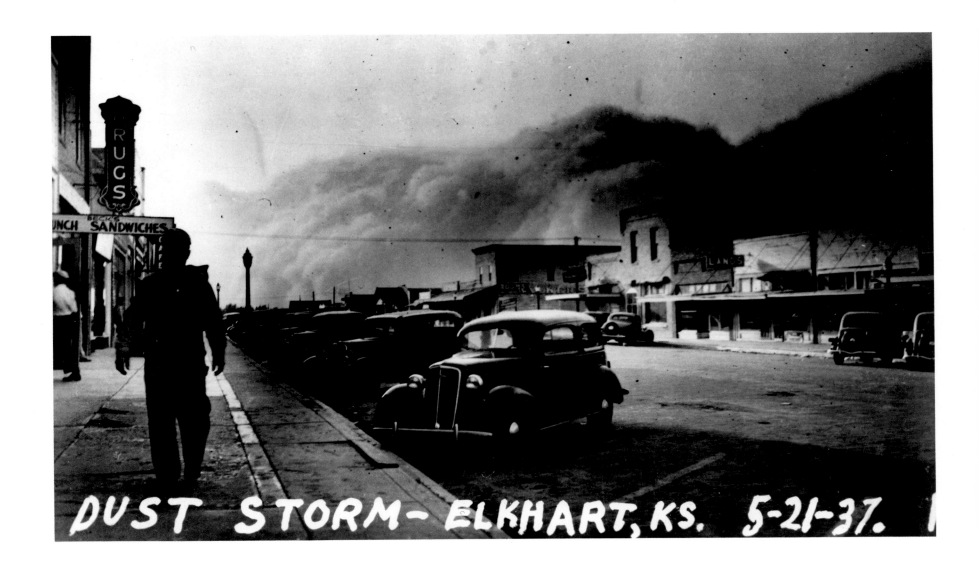

DUST STORM - ELKHART, KS. 5-21-37.

3
Dust storm
Elkhart, Kansas
May 1937
Acquired for the
FSA collection from
an unidentified
photographer

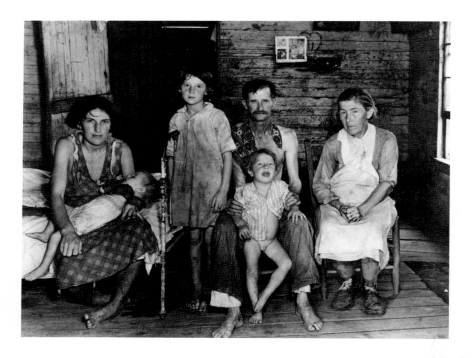

there was little public awareness of the problems tenant farmers faced. So Tugwell established what he euphemistically named the "Historical Section" of the FSA, charged with photographing and publicizing the plight of the tenant farmer. At its heart, this was an effort in propaganda. Tugwell hired a colleague and protégé from the economics department of Columbia University, Roy Stryker, to head the section; and Stryker took the section well beyond its original mandate. Over the next nine years—first in the Resettlement Administration, then in the Farm Security Administration, and finally as part of the Office of War Information—Stryker and his photographers produced and disseminated images both of the everyday, unchanging aspects of life and of the extreme economic, social, and environmental conditions of the thirties. They produced one of the largest, most emotionally powerful, and most widely known collections of photographs ever assembled.

Because of the quality of the photographers Stryker hired, and because he sent them into regions (like the Great Plains) that were not yet covered extensively by the major news organizations, FSA photographs were published in newspapers across the nation and by such influential magazines as *Life, Look,* and *Survey Graphic.* Arthur Rothstein photographed the Dust Bowl and showed city dwellers how work stopped and farmers ran for the house when a dust storm came up (page 19). Dorothea Lange traveled with and photographed the Dust Bowl migrants as they left the plains for California and the West; and she was there when they searched frantically for the few jobs left when they reached the "promised land" (pages 30–36). Walker Evans traveled the South and East and produced carefully crafted images of small towns and tenant farmers.

4
Bud Fields and
his family
Hale County,
Alabama
Summer 1936
Walker Evans

5
Ditched, stalled
and stranded
San Joaquin Valley,
California
1935
Dorothea Lange

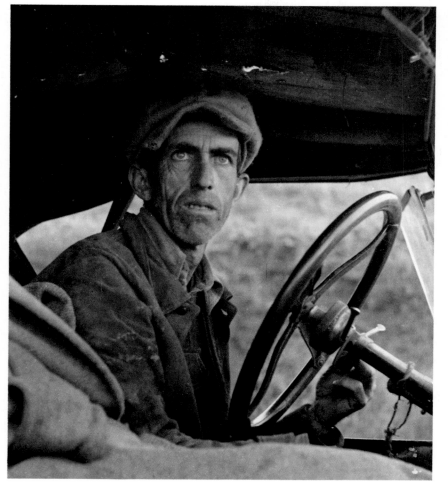

Ben Shahn, John Vachon, Marion Post Wolcott, Russell Lee, Jack Delano, John Collier, Jr., Carl Mydans, and Gordon Parks were also among the photographers whose work is included in the FSA collection.

The FSA photographs have become visual touchstones by which we understand the upheavals caused by economic and climatic disasters. The collection has become a standard source for the authors of history texts. With each new edition, a new generation of students has learned about the human costs of the Depression through the FSA photographs.

This remarkable collection came about because of Stryker's special blend of talents: his administrative ability, his gift for leadership, and his understanding of the nature of documentary photography. Stryker was never a photographer. He did, however, recognize and hire excellent photographers; beyond that, he was able to pry loose from the bureaucracy the money and administrative support they needed to stay out on the road producing photographs. Stryker also knew what kinds of photographs were needed to document the condition of tenant farmers, he acquired photographs from outside sources as well as hiring staff photographers, and he demanded that his photographers understand thoroughly the economic, social, and political aspects of their subjects. Under this guidance, many of the FSA photographers produced the best work of their careers. This work and Stryker's approach to it has, in large part, defined the nature of documentary photography.

Stryker understood that an effective documentary photograph exists within, and derives much of its meaning and power from, its context. I take this notion of context to be almost a definition of documentary photography, one of the most misunderstood and misappropriated terms in the history of art.

Dorothea Lange's photograph of a worried man behind the wheel of an old car, for instance, is a faithful and moving representation of the man's emotional state. Yet, with no more information than the photograph supplies, the viewer might assume that his expression was caused by nothing more serious than a traffic jam or flat tire.

Lange's caption for the photograph—"Ditched, stalled and stranded, San Joaquin Valley, California, 1935"—provides us with a little more information. We now know the immediate cause of his distress, and the fact that he is "stranded" makes his situation seem more desperate. If we also know, either from Lange's other work or from other sources, that the San Joaquin Valley was one of the major agricultural valleys to which migrant farm workers flocked in search of jobs, we can begin to understand the depths of his desperation. We can assume that he, like many others during the Depression, had been displaced and was on the road looking for whatever work was available. To be stalled and stranded in this situation was to be deprived of one's means of livelihood, one's only hope. This is the context of the photograph.

The documentary photographer must understand the context of the situation being photographed and must be able to convey that context to the audience. That can be accomplished by the way the subject is photographed, by the choice of words used in conjunction with the photo, or by the selection and sequencing of other, related photographs.

Stryker understood this. Before he sent photographers into the field, he made sure that they understood the environmental, social, economic, and political factors that helped define the particular region. Stryker had long conversations and carried on extensive correspondence with his photographers. He also prepared detailed shooting scripts that outlined the research he expected of the photographer and the kinds of images the collection needed.

In July 1936, Arthur Rothstein was in the plains states and had already produced and shipped back to Washington a series of dramatic photographs of the Dust Bowl (pages 18–21). Yet, in his letters, Stryker was still trying to find ways to document the effects the Dust Bowl was having on people.

Besides the suggestions which you may gather from the outlines forwarded, we [Stryker and Ed Lock, Stryker's assistant] suggest the following things to look for: foreclosure notices, more sale signs posted on buildings. I don't suppose it is possible, but it would be very interesting if these sales could be tied up with the drought. I do hope you have the good luck to be on hand when some family is packing up, ready to leave for parts more moist.[3]

More than a year later, writing to Russell Lee in the northern plains states, Stryker was still concerned.

In looking over Arthur's pictures on dust and drought I find that there is not a great deal that portrays the effect of dust and drought on people. Your work, I believe, will help us close this particular gap. Arthur's pictures of the dust and its effect on farm buildings and land are very excellent, but we do need an addition of more pictures on people, their homes, and their children.[4]

Lee responded by "making a survey of families of farm laborers who have moved to towns and live in shacks," as he put it in his reply to Stryker. "In general, I shall concentrate my work upon the effects of drought upon the people as you have suggested."[5] Some of

those photographs are included on pages 48–49 and 72–77.

A shooting script that Stryker wrote before a trip Marion Post Wolcott made to the plains in 1941[6] shows how much research he expected from his photographers. The script was produced late in the life of the FSA, after some of the worst effects of the Depression had been alleviated by the expanding war economy. Stryker's concerns had therefore changed somewhat, but his thoroughness had not. He listed nine subjects "to be watched for in the plains country."

1. Shots which give the sense of great distance and flat country (remember Lange's two mailboxes)
House; barn and windmill on horizon; lots of sky
Row of telephone poles
Railroad track, telegraph poles stretching to horizon . . .
2. Search for ideas to give the sense of loneliness experienced by the women folks who helped settle this country. This idea might be developed around an abandoned dwelling on a plains homestead. Look for interiors where the wallpaper still hangs to wall or ceiling. Try to combine an interior & exterior view through an open door or an empty window space. A shot of barn or other buildings in state of near ruins from house interior. Remember that the windmill is a symbol of the struggle for water. One in ruins is also a symbol.
3. Pictures along streams—trees and little "shoestring" ranches indicating the importance of water (and the friendliness of water, too).
4. Remember that the cottonwood tree belongs to this country, but it must have water. . . .
5. Fences. It was the barb-wire & the homestead law which changed the picture of the plains in the period 1870–1900. The country went under fence & the plow & then came the dust storm. . . .
6. Water is the great need out here. Watch for water tank in town. . . .

7. Wheat. *You must be in Kansas for a while during the wheat harvest.*
Again get the sense that there is nothing in the world that matters very much but wheat. Wheat & wheat just as far as the unaided eye can see. . . .
8. People
The spare, bronzed and wrinkle-faced men of this section. Man on combine—face shaded by straw hat. Youngsters on road waiting for school buses. . . .
9. Small Town (Important)
Grain elevators
R.R. Station
A few trees
Scattered houses
Implement Store—tractors and combines
Tractor repairs station
Church (usually an architectural monstrosity)
Doctor's Office
Store windows
Schools (usually quite poor)

The bibliography that Stryker wrote for Marion Post Wolcott ran to two pages, listing Walter Prescott Webb's *The Great Plains,* Everett Dick's *The Sod-House Frontier,* Mari Sandoz's *Old Jules,* O. E. Rölvaag's *Giants in the Earth,* and Hamlin Garland's *A Son of the Middle Border,* as well as books by Willa Cather, Clyde Davis, Paul DeKruif, and John G. Neihardt. In addition, each photographer was told to buy a copy of J. Russell Smith's socioeconomic geography book, *North America,* and it became a standard source of regional information.[7]

In short, Stryker expected his photographers to understand the context in which the plains people lived their lives. It is this attention to context that sets photographs that truly document their subject apart from photographs done in a "documentary style."

This book contains documentary photographs, and I have tried to present each within its own

context. In addition, the photographs exist within another context imposed by the direct pairing of photographs of similar subjects at different times. The pairing can create a thorny problem because each image must stand on its own and yet must relate to the other in some way.

For example, the photograph of Fritz Fredrick in 1936 on page 46 needs its caption to explain that his outstretched hand is showing "how high his wheat would grow if there were no drought." That's the context of that photograph. When I photographed Fritz in 1977 the context had changed. Although the drought was no longer a threat to his livelihood, high agricultural expenses were, and that became a context for my photograph. Yet the two images still had to relate to each other. So I asked Fritz to stand in the same field with his new combine behind him and adopted the same frontal, formal pose that Rothstein had used. We can see how high his wheat is and how large the combine is; he tells us what that means to his farming operation.

In 1942 the United States had just entered World War II and a recruiting billboard near Aberdeen, South Dakota (page 110), reminds us of the patriotic fervor that war inspired. By 1975 two other wars had happened, Korea and Vietnam, and a photograph of a recruiting billboard in the middle of a feedlot takes on a somewhat different meaning. Seen together, these two photographs can tell us something about the change in attitude many people have toward the military, and that is a context separate from the meaning each photograph engenders separately.

The idea of photographing the same subject matter at different times is not one I can lay exclusive claim to. Stryker himself, in a shoot-

ing script he wrote in 1936, proposed that his people do a series of photographs "showing the relationship between time and the job. This would include such things as pictures taken of the same people every ten years, showing how people age in their work." That project was never begun.

At least one FSA photographer, John Vachon, had the urge to photograph the same place that had been photographed earlier. In 1937, he was a young photographer on his first assignment from Stryker photographing an FSA project in Georgia.

On the way back, I had to change trains, and there was a three-hour wait in Atlanta, where I'd certainly never been before. I hired a taxi for five dollars to drive all over the city. I was looking for something. In 1935 Walker Evans had photographed two identical weathered frame houses with ornamental woodwork, half-hidden by two large billboards, on one of which was Carole Lombard's face with a black eye. I found the very place, and it was like finding a first folio Shakespeare. The signs on the billboard had been changed, but I photographed it, and it's in the file.[8]

I can understand his excitement. For more than eight years I have been tracking down people and places that just happened to be photographed forty years before. When I was lucky enough to find some of them it was a little like being carried suddenly backward in time and being and allowed to sense something of how life was then. In a way, the FSA photographs were a medium through which I made contact.

Sometimes I felt more like a detective than a photographer. The detective work began with the FSA captions. All of the captions in the collection give some basic information—where the photo was taken, when, and by whom. In many cases the photographers used the captions to record some of the context of the

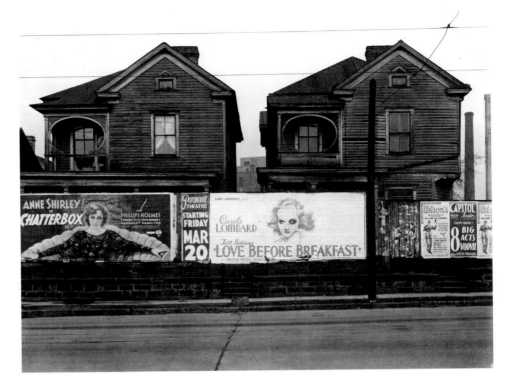

6
Billboards
and frame houses
Atlanta, Georgia
March 1936
Walker Evans

7
Houses and
advertisements
Atlanta, Georgia
May 1938
John Vachon

photograph: why this situation had developed or what the people in the image had said. Arthur Rothstein, for instance, gives us some sense of why Vernon Evans was going to make Oregon, "or bust" trying (pages 24–25). In a few cases, the photographers noted the names of their subjects; that made my job much easier.

Yet even when I had the names of the subjects, there were problems. A few of the people I was able to find did not want to talk with me. Others in the FSA photographs had been so uprooted by the Depression that it was impossible to find friends or relation who remembered them and had kept track of their wanderings. Others did not survive. And, like Vachon, to find a specific place in an FSA photograph I sometimes had to do a lot of driving around. I drove well over thirty-five thousand miles, up and down and across the plains, as well as out to California and Oregon to find Dust Bowl refugees. Dorothea Lange, in particular, did not record her subjects' names, although she kept meticulous notes in the field about their situations and what they said. Whether this was because she respected their privacy or simply did not want to know their names, it made my job very difficult. Lange was assigned to produce most of the FSA work on migrants, and so her photographs were vitally important to my project. I found some of her subjects through a curious mixture of luck and ingenuity.

Perhaps the most famous FSA photograph is Lange's image of "Migrant Mother" (pages 30–31). Lange had never written down her name. But Florence Thompson knew that she was the woman in the famous photograph. Her family persuaded her to take her story to the local newspaper, the *Modesto* (California) *Bee*. The *Bee* ran a story about her, other newspapers picked it up, and the news finally got to me.

In other cases I had to plant the story myself. I sent several of Lange's photographs to newspapers in the locality where the image had been made, along with a press release asking if readers could identify the subject of the photograph. In this way I was able to find people like Nettie Featherston (pages 32–34) and Ray Turpen and Walter Ballard (pages 22–23).

There were other strokes of luck for which my research had not prepared me. One such case occurred in connection with the Allen family of Custer County, Nebraska. In 1979, the Nebraska Educational Television Network began filming a program featuring the work of six photographers who had worked in the state.[9] My project was included, along with the work that Arthur Rothstein did for the FSA in Nebraska, and that of the remarkable pioneer photographer Solomon Butcher. Butcher came to Custer County, Nebraska, in 1880, when it was just being settled. An amateur historian, he understood the importance of the events that were happening around him and decided to document the settlement process. He set out to photograph every settler in the county, a task that consumed him from 1880 to 1900.

Because of the television production, I began thinking about Butcher's work, and I remembered one of the first images I had ordered from the FSA collection—a photograph that Arthur Rothstein had taken in Custer County. Through the local newspaper I was able to identify the man Rothstein had photographed and to get in touch with his daughters who still lived in the county. Then, with the name of Rothstein's subject, I went to the Nebraska State Historical Society, where the Butcher collection is housed. And there it was, Butcher's photograph of the same family almost forty years before Rothstein had visited Custer County.

Butcher photographed the Andrew Allen, Sr., family in 1887, only a few years after they had immigrated to the dry plains from Ireland.

Andrew Allen, Jr., was eleven and stood third from the left, beside his father, in Butcher's photograph. In 1936, Andrew, Jr., had taken over his father's farm, but was having a hard time holding on to it in the face of the Depression. He took out a loan from the Farm Security Administration. That same year, Arthur Rothstein was assigned to photograph FSA programs in Nebraska and the other plains states. Rothstein seemed to understand some of the uncertainty that Andrew, Jr., must have felt, and the photograph conveys that feeling. Forty years later, in 1979, the farm had passed out of Allen family hands, but two of Andrew's daughters, Margaret Collier and Lucille Farmer, still lived within a few miles of the original farmstead. To be able to continue the Allen family chronicle with Arthur Rothstein present was a pleasure that I did not expect.

It has been more than ninety years since Solomon Butcher first photographed the Allen family. During that time, the family has struggled to make a living on the plains. To my mind, they are worthy of the attention of three generations of photographers. Each of us in turn has tried to understand that struggle and the struggle of countless families like theirs. We have tried to understand the contexts within which they lived their lives, and then to present those facts to our viewers.

This book began in 1970. I had seen an exhibition of FSA photographs in Lincoln, Nebraska, my hometown; on a vacation trip to Washington, D.C., that summer, instead of joining my

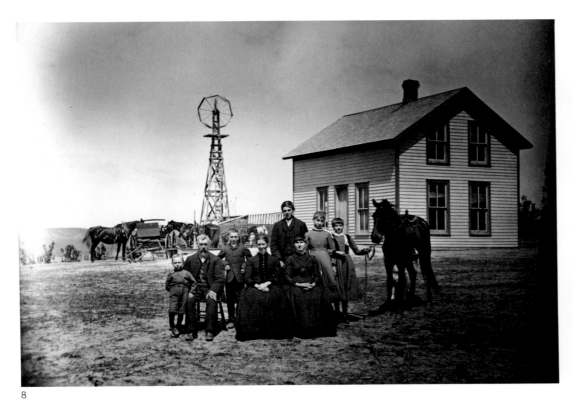

8

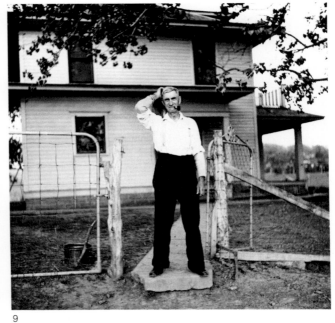

9

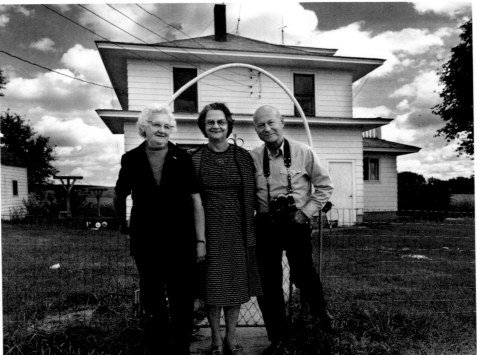

10

8
Mr. Allen
Custer County,
Nebraska
1887
Solomon Butcher

9
Farmer who has
benefited by an FSA
rehabilitation loan
Custer County,
Nebraska
May 1936
Arthur Rothstein

10
Margaret Collier,
Lucile Farmer, and
Arthur Rothstein
Custer County,
Nebraska
September 1979

family's sightseeing excursions, I spent my days in the Library of Congress going through the FSA collection. I purchased copies of about fifty FSA photographs of Nebraska. At home, I kept looking at those images and wondering what I could do with them.

My first photograph used in this book was made in June 1975, at the FSA farmstead in Falls City, Nebraska. Over the next several years I expanded my range, eventually making photographs in all ten Great Plains states and on the West Coast as well. My last trip for the project was to Pie Town, New Mexico, in October 1980.

Dust Bowl Descent is not the final chapter of the project begun by FSA photographers half a century ago. The Plains continue to change to accommodate new industry, new people, and new fashions. Socially and privately, triumphs and tragedies repeat. Water and drought are again national concerns. Florence Thompson, the grim "Migrant Mother" of 1936 and smiling woman of 1979, later suffered a stroke and required medical care so expensive that her family was forced to appeal for money. People donated more than $15,000, recalling her face from Dorothea Lange's famous photograph. Florence Thompson died in Scotts Valley, California, on September 16, 1983.

The traveling I have done for the book has given me a fuller appreciation of the plains environment, of the landscape of the plains. But, home again and sorting through the photographs, I remember best the people who opened their lives to me.

My father had told me about growing up in the Depression. Sitting in living rooms in Felt, Oklahoma, or Williston, North Dakota, people told me hundreds of stories about the hard times they had been through, and I began to realize that I was not hearing merely the stories a parent tells to unimpressed children—that, for thousands of people, my father's stories were typical and true. Through these people who had survived a terrible social upheaval, I began to understand the depth of the human costs of the Depression.

I began to see the differences between my grandfather's photographs of my father growing up and my father's of my sisters and me. I could compare the FSA photographs and my own in much the same way: that is how we were then, and this is how we are now. With the photographs and the things people told me, I was groping toward a broader definition: this is where we live, and this is who we are.

NOTES

1. Berta Asch and A. R. Mangus, *Farmers on Relief and Rehabilitation,* Works Progress Administration Division of Social Research, Research Monograph 8 (1937), pp. 4–6.

2. David E. Conrad, *The Forgotten Farmers: The Story of Sharecroppers in the New Deal* (Urbana: University of Illinois Press, 1965), pp. 27–36.

3. Stryker to Arthur Rothstein, July 31, 1936, Roy Stryker Collection, University of Louisville Photographic Archive.

4. Stryker to Russell Lee, October 12, 1937, Roy Stryker Collection, University of Louisville Photographic Archive.

5. Russell Lee to Stryker, October, 1937, Roy Stryker Collection, University of Louisville Photographic Archive.

6. Roy Stryker Collection, University of Louisville Photographic Archive.

7. F. Jack Hurley, *Portrait of a Decade* (Baton Rouge: Louisiana State University Press, 1972), pp. 58, 60.

8. John Vachon, "Tribute to a Man, an Era, an Art," *Harper's,* September 1973, pp. 96–99.

9. Along with those mentioned above, the program, "Sandhills Album," highlighted the work of contemporary Nebraska photographers Margaret MacKichan, Lynn Dance, and Bob Starck.

Dust Bowl Descent

"The Great Plains are a land that you love or you hate. In the winter come blizzards that are so blinding that you cannot see the length of your automobile.... In the spring there is usually a wind-storm or two ... strong enough to blow half the water out of a bucket.... All summer long the wind blows and blows, and the sunshine glares. If the rain comes it is in showers which are soon over. Meanwhile there is little else to do but watch the weather. Many a settler's wife has paced the floor of her shadeless kitchen until she wore it through, and there is a high record of women's insanity in some parts of the plain.

"On the other hand, there are people, especially I think men, who love the plains. There is a charm, somewhat like the charm of the sea, about the endless, rolling hills and the horizon devoid of any objects. To some this gives a sense of space, of largeness, of being near to nature, to the Infinite, to God."

From J. RUSSELL SMITH, *North America*

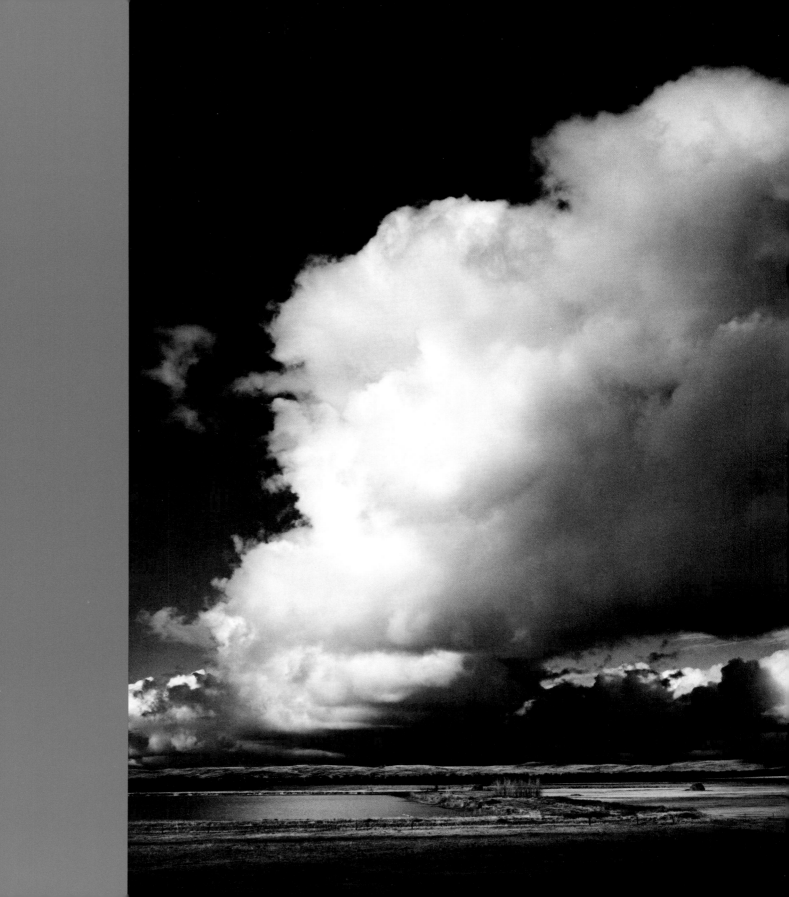

11
Storm cloud
Near Paxton,
Nebraska
Fall 1975

12
McHenry County,
North Dakota
October 1940
John Vachon

13
Roadside crosses
Rosebud County,
Montana
October 1979

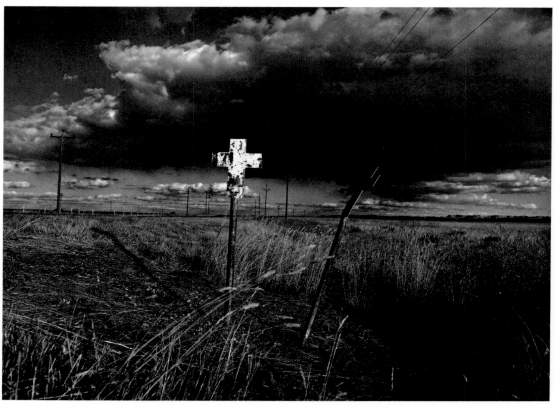

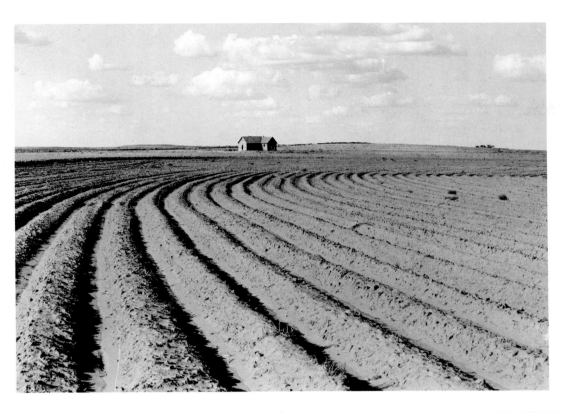

14
Power farming displaces
tenants from the land in the
western dry cotton area
of the Texas Panhandle.
Childress County, Texas
June 1938
Dorothea Lange

15
Abandoned house in the
middle of a cotton field
Childress County, Texas
August 1979

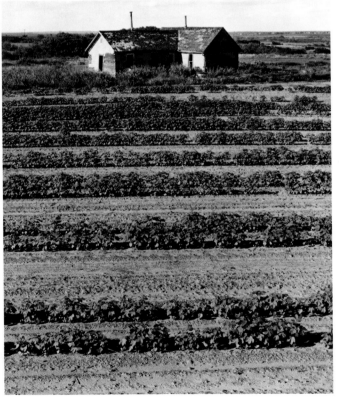

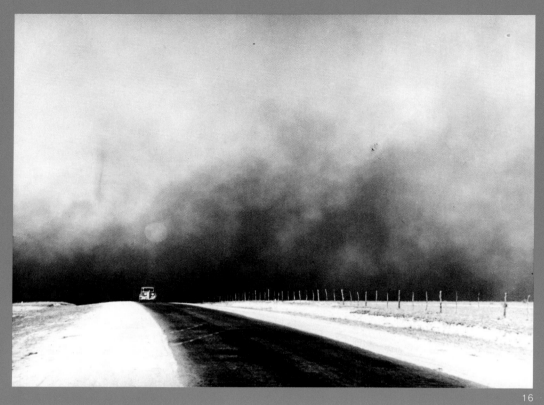

16

16
Heavy black clouds of
dust rising over the
Texas Panhandle
Dalhart (vicinity), Texas
March 1936
Arthur Rothstein

17
Blowing snow in the
Texas Panhandle
Near Dalhart, Texas
January 1979

18
Fleeing a dust storm
Cimarron County, Oklahoma
April 1936
Arthur Rothstein

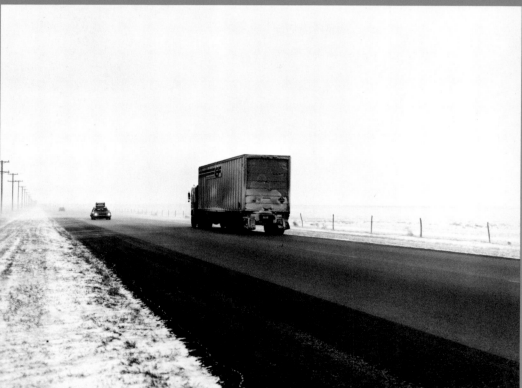

17

"The region of the Great Plains is characterized
by rainfall insufficient for the agriculture of the
corn and wheat belt types. It is a land of con-
siderable variation in rainfall. In some places
the rain is only 10 to 12 inches on the average.
In other places it is 16, in others again 18—
facts which make a very great difference in the
lives of men. But averages do not tell the whole.
Averages rarely happen. The freaks of the
season decide man's chances."

From J. RUSSELL SMITH, *North America*

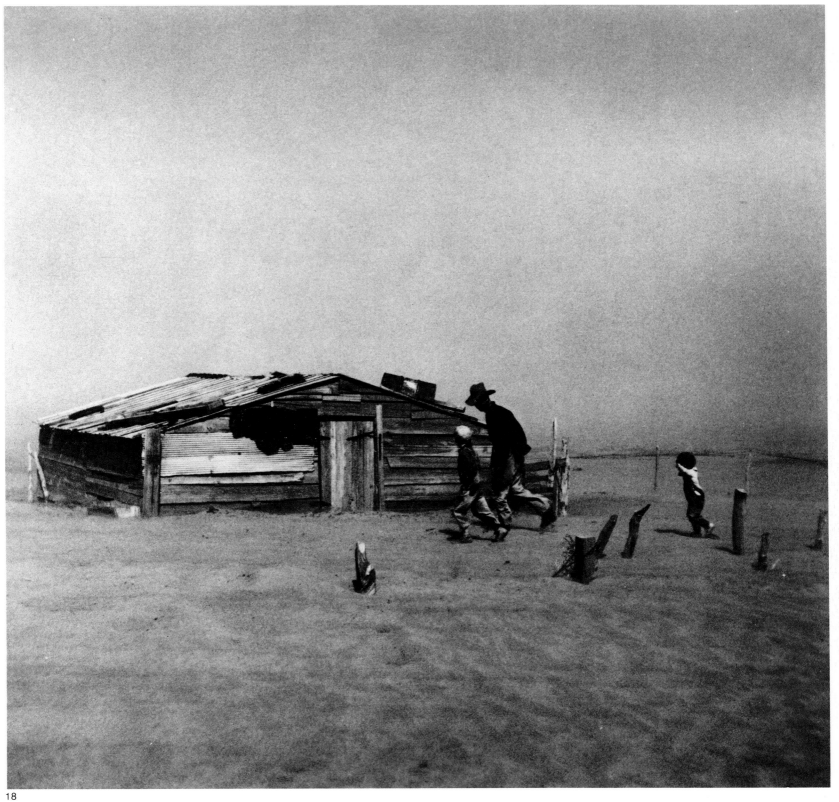

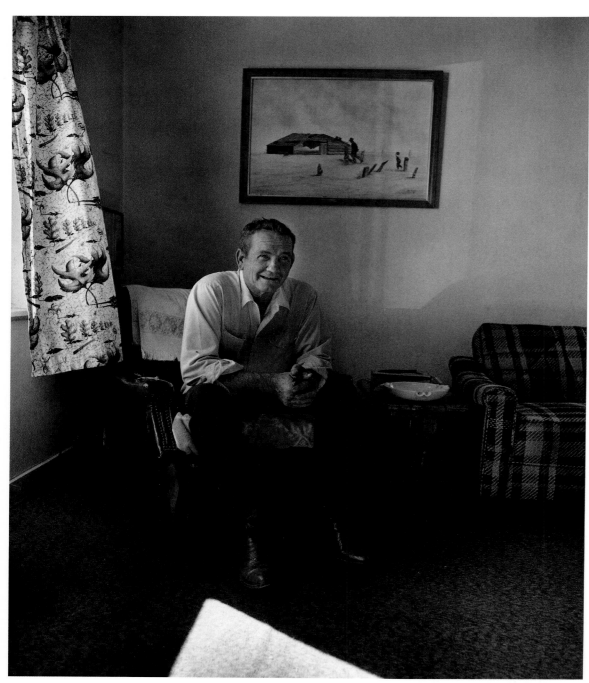

"All the days was about alike then. For a three-year-old kid, you just go outside and play, dust blows and sand blows, and you don't know any different. One evening a black duster come in here from the north. We had kerosene lamps. And it got so dark you couldn't see with kerosene lamps.

"Last spring we had some pretty bad days. They weren't the old black dusters, but I mean, there was plenty of dust in the air.

"I don't really know why I like living here. I guess just 'cause this country's home. Dad always said that if anybody ever come here and wear out two pairs of shoes here, they'd never leave. Back in the thirties, my dad had some relatives in California that was fairly wealthy, an aunt and uncle, and they wanted him to get outa here. They said they'd pay his way out to California, the whole family, but he said he wouldn't go. He was just a hard-headed Coble, I guess. He was pretty independent. I just imagine he thought that if it was going to be somebody else's money, why, he wasn't gonna go, period."

DARREL COBLE

19

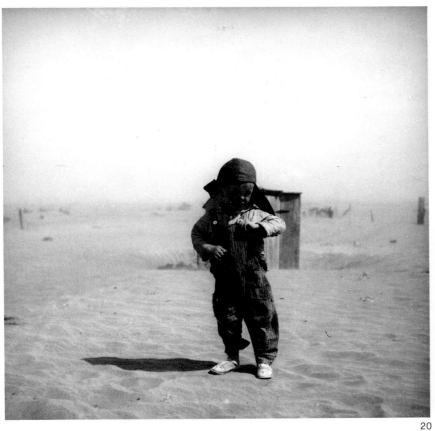

20

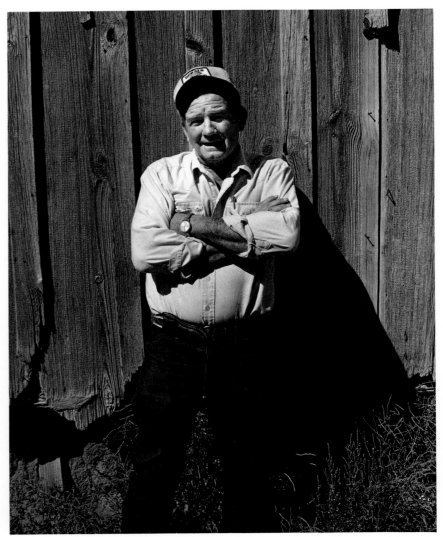

21

19
Darrel Coble in his home.
On the wall is a painting by
a local woman copied from
Rothstein's photograph
"Fleeing a dust storm."
Cimarron County, Oklahoma
September 1977

20
Son of a farmer [Darrel
Coble] in the dust bowl area
Cimarron County, Oklahoma
April 1936
Arthur Rothstein

21
Darrel Coble on his
original home place
Cimarron County, Oklahoma
September 1977

22
Darrel Coble, the youngest
boy in the 1936 photo-
graph, in a sand drift near
his former home. In 1977
he lived about twelve miles
from where the photograph
was taken. Arthur, his father,
and Milton, his older brother,
had died; Darrel died in 1979.
Cimarron county, Oklahoma
September 1977

22

Former Texas tenant
farmers displaced by power
farming. [From left:
O. B. Welch, Cephus Mont-
gomery, Raymond Turpen,
Vernon Scott, D. W. Welch,
and Walter Ballard.] All
displaced tenant farmers,
the oldest thirty-three. All
on WPA. They support an
average of four persons
each on $22.80 a month.
"I can count twenty-three
farmers in the west half
of this county that have
had to leave the farms to
give three men more land."
[From Dorothea Lange and
Paul S. Taylor, *American
Exodus*]
Hardeman County, Texas
May 1937
Dorothea Lange

24
Raymond Turpen
and Walter Ballard
Hardeman County,
near Goodlett, Texas
July 1979

"Before that picture we had a farm rented. We had teams. But when the tractors come in, these landlords wanted all the land to farm themselves. That's what I blame on losing the place. I started on WPA [Works Projects Administration] in '36 and worked on and off for a couple of years for $21 a month. It was a good experience. But these farmers, waiting for their government checks to come in, why, they'd fuss about us working on the WPA. They wanted us to lay them shovels down, didn't think we was earning our pay. Well, if they'd have got out there and stayed with us all day, they'd have thought they was earning their pay."

RAYMOND TURPEN

"The hardest work I've ever done in my life was on the WPA, hardest and the heaviest work. A lot of what we built is still around.

"I used to ride the rails looking for work. I loved it; it'll get in your blood. You're not agoing anywhere, you don't care, you just ride. It's paid for. You're going to eat in the hobo jungles, that was more than you was doing at home, probably. First time I caught a freight was in Chadron, Nebraska, I and another boy. We was scared. We seen a freight sitting, and there was so many people on it, it looked like blackbirds. We was afraid we'd get throwed off or beat up. But we went over and got on, and believe it or not, when we got ready to go that old brakeman hollered, 'All aboard!' Then we felt at ease. It wasn't always like that. I been hijacked by them railroad bulls [hired guards] in the yards, and they get rough. See, there was so many of us on the rails, they couldn't let you congregate in one town."

WALTER BALLARD

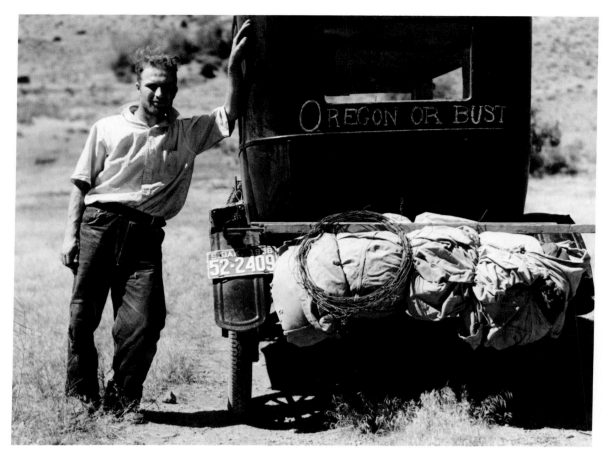

"Well, we was all without jobs here at the time. The jobs was so few and far between that you couldn't buy a job. We'had friends that we knew out in Oregon, and we decided we was going to go out there and see if we could find work. We had $54 between the five of us when we started out, and when we got to Oregon, I think we had about $16 left. We had absolutely no idea what we was going to do.

"We got out around Missoula, and we was having a good time. There was this car sitting alongside the road and a guy sleeping in it, so we honked and hollered at him, having a big time. Pretty soon this car was after us. Well, we seen he had an emblem on the side of the car, and we'd heard they was sending 'em [the migrants] back, wasn't letting 'em go through. So, we thought, 'Here's where we go back home.' He motioned for us to pull over. Anyhow, he come over and introduced himself—Arthur Rothstein was his name—and said he was with the Resettlement Administration. This 'Oregon or Bust' on the back end was what took his eye. He asked us if we cared if he took some pictures of us. That fall or winter, why, these pictures started showing up in the different magazines and papers.

"In the winter of '45, my father passed away. I come back and kind of took over the farm and helped out here. I've been here ever since. We've had our ups and downs, I guess. I've been hailed out probably five, six times, and dried out three, four years, and one year we rusted out."

VERNON EVANS

25
Vernon Evans with his family of Lemmon, South Dakota, on Highway 10, left the grasshopper-ridden and drought-stricken area for a new start in Oregon or Washington. They expect to arrive at Yakima, Washington, in time for hop-picking. They live in a tent and make about 200 miles a day in a Model-T Ford.
Missoula (vicinity), Montana
July [18], 1936
Arthur Rothstein

26
Vernon Evans on the farm his father homesteaded and to which Vernon returned after nine years in Oregon
Lemmon, South Dakota
July 18, 1977

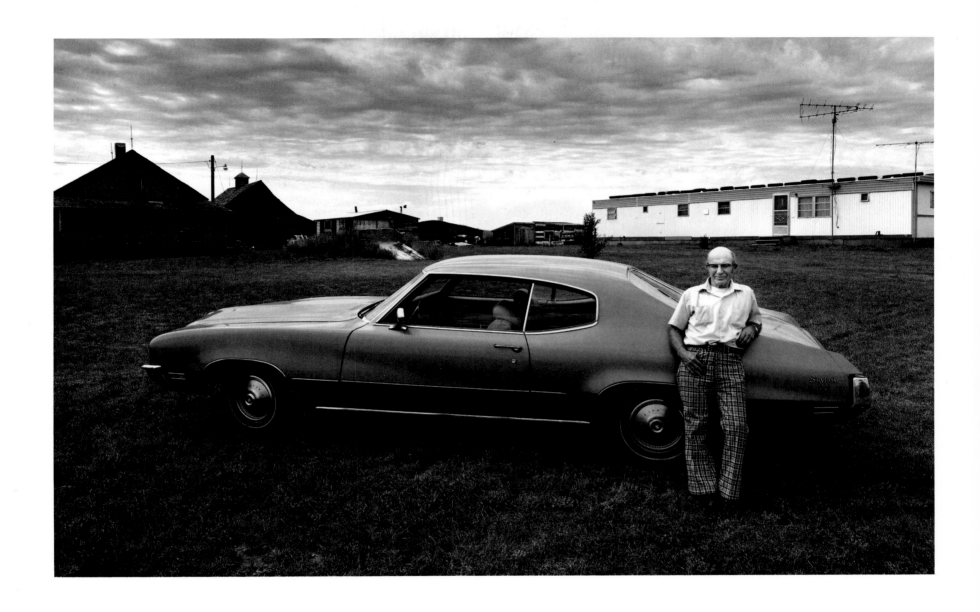

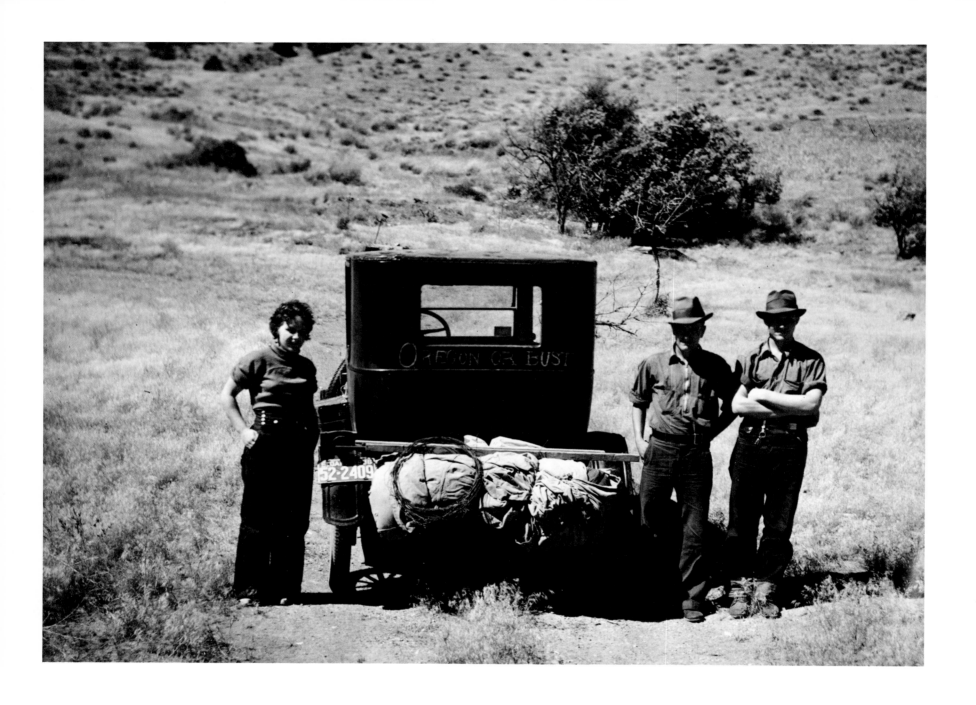

"My dad used to walk the floor when those dust storms were blowing and say, 'There's a lot of real estate exchanging hands today.' The year before we left, my dad had a corn crop going pretty good. The grasshoppers hit, and dad went to town and bought corn knives for all us kids. He figured if we'd get that corn chopped down and piled up for fodder, the grasshoppers would leave it alone. [Crying.] Well, they didn't. We worked, but we couldn't keep ahead of them. They ate it right in the shock. They ate every bit of it. I don't even like to think about those days. We had friends who had come out to Oregon the year before, and they'd write back what a great country it was. There was grass up to the cow's belly, and there was fruit free for the picking. And there was work in the fruit orchards. We had nothing, came with nothing.

"We go back to South Dakota every once in a while to visit, but I wouldn't want to live there. No way! No way! I just get that feeling every time I go back, like it used to be. I know it's not quite that bad any more, but . . . no way. I tell Vern and Flora all the time that they should have stayed out here."

MARIE JOHNSON

27
Leaving South Dakota for a new start in the Pacific Northwest. [From left: Marie Braught, Frank Braught, and Ervin Zimmerman.] Missoula (vicinity), Montana
July [18], 1936
Arthur Rothstein

28
Marie (Braught) Johnson and Frank Braught on a bluff overlooking the Columbia River. Flora Evans, Vernon's wife, is the sister of Marie and Frank, and they made the trip together. Ervin Zimmerman is deceased.
The Dalles, Oregon
July 1979

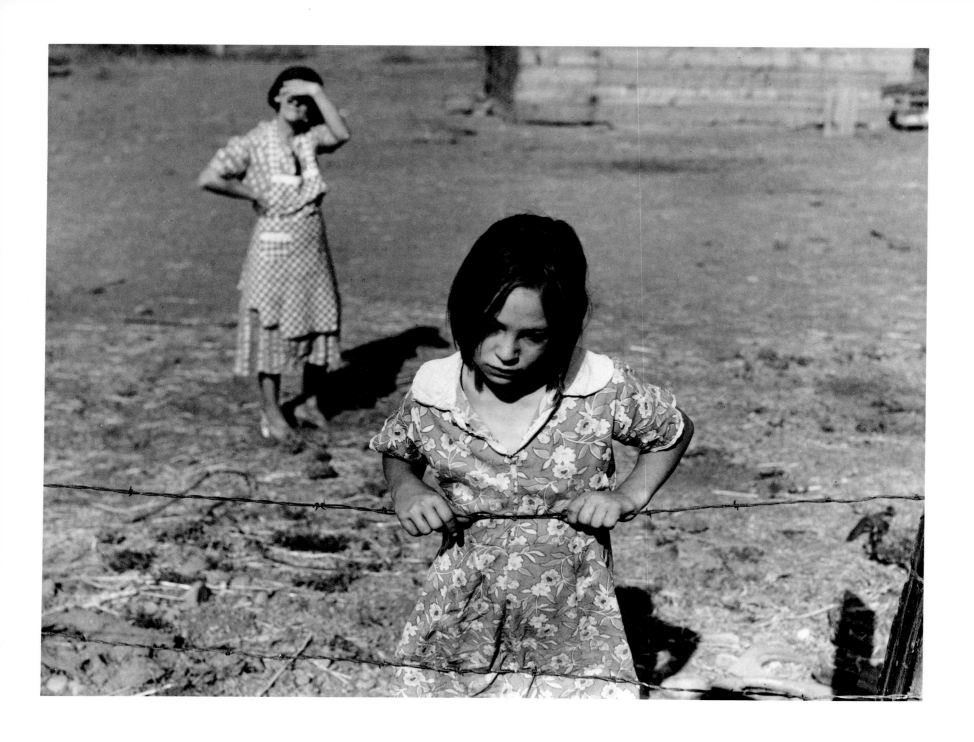

"Back on the Colorado plains it was terrible. We survived there as long as we possibly could. But we had dust storms and droughts—the wind would come and pick up our crops and just absolutely destroy them, and the neighbor right next to us, it would miss entirely. It just came to the point where we couldn't live any more back there. My dad's sister was out here already, and she wrote back saying this was the land of milk and honey. I guess we were doomed to come to the state of Washington. And after being here I can't think of going anywhere else to live.

"When we first moved out here, my dad had rheumatism real bad. He almost died, and we had to go on relief. We got food and sometimes clothes. And mother would make clothes out of flour sacks, dresses and underpants and everything. My older brothers and sisters, we all worked in the orchards whenever we could. I was about ten, and the little ones would crawl up in the middle of the tree and pick while the older ones were on the outside on ladders."

LOIS (ADOLF) HOULE

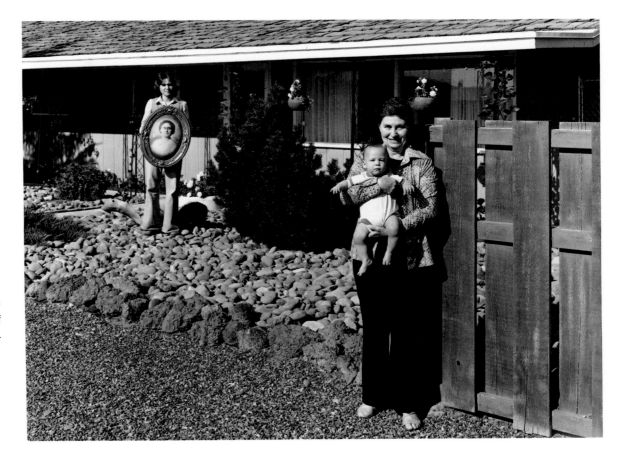

29
Child [Lois Adolf]
and her mother
Wapato, Yakima Valley,
Washington
August 1939
Dorothea Lange

30
Lois (Adolf) Houle,
in front, holds her
grandson Kevin, while
her daughter, Jody
Sellers, holds a photo-
graph of Lois's mother.
Toppenish, Yakima Valley,
Washington
June 1979

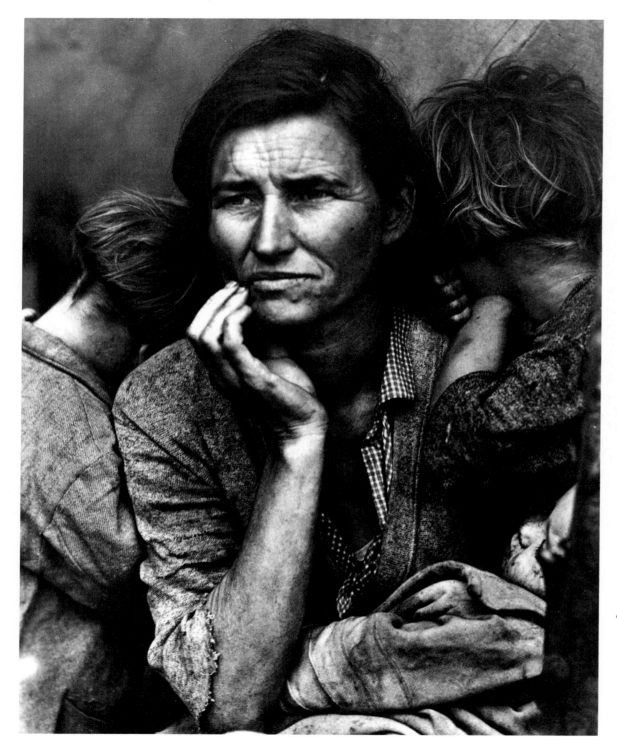

"I left Oklahoma in 1925 and went to California. The Depression hit just about the time them girls' [her daughters'] dad died. I was twenty-eight years old, and I had five kids and one on the way. You couldn't *get* no work and what you could, it was very hard and cheap. I'd leave home before daylight and come home after dark—grapes, 'taters, peas, whatever I was doing. Barely made enough each day to buy groceries that night. I'd pick four or five hundred pounds of cotton every day. I didn't even weigh a hundred pounds. We just existed—we survived, let's put it that way.

"When Steinbeck wrote *The Grapes of Wrath* about those people living under the bridge at Bakersfield—at one time we lived under that bridge. It was the same story. Didn't even have a tent then, just a ratty old quilt. I walked from what they'd call the Hoover camp at the bridge to way down on First Street to work in a restaurant for 50 cents a day and leftovers.They'd give me what was left over to take home, sometimes two water buckets full. I had six children to feed at that time."

FLORENCE THOMPSON

"Women, especially, would give to their children and they would do without. When we were growing up, if mother weighed one hundred pounds, she was fat."

RUBY SPRAGUE (daughter of Florence Thompson)

"She worked hard, brought us up and kept us together. We all have good jobs and we all own our own homes. And none of us have ever been in trouble."

KATHERINE McINTOSH (daughter of Florence Thompson)

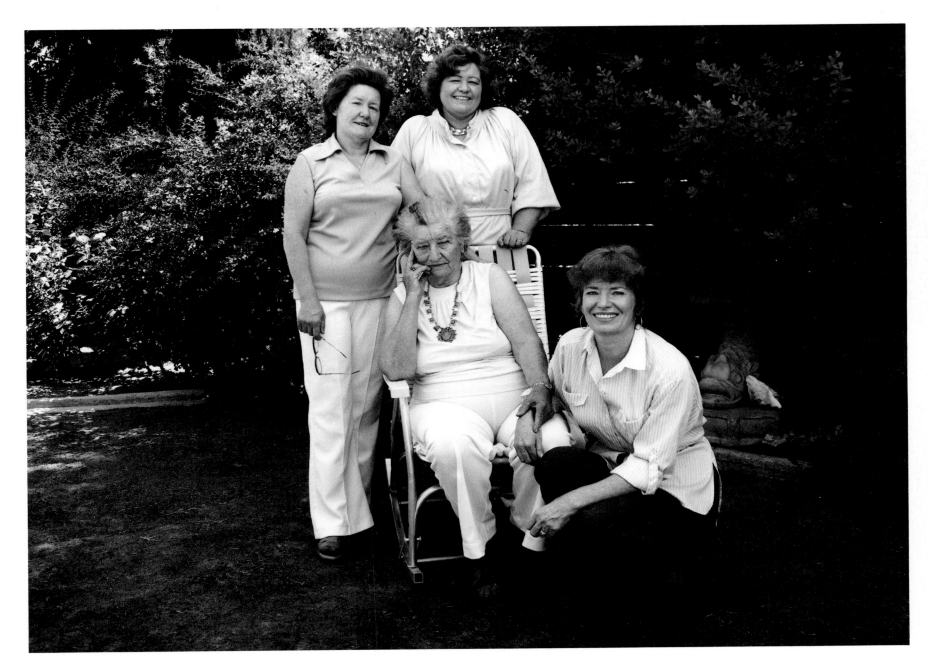

31
Migrant Mother
[Florence Thompson
with her daughters:
Norma, in her arms;
Katherine, left;
and Ruby]
Nipomo, California
March 1936
Dorothea Lange

32
Florence Thompson
and her daughters
Norma Rydlewski (in
front), Katherine McIntosh,
and Ruby Sprague,
at Norma's house
Modesto, California
June 1979

"We were on the road, just trying to find something. We stopped at a filling station in Carey, and this cotton grower come by and seen our bedding on top of the car. He asked if we'd like to go out and pull some bolls [harvest the cotton] for him. We did that all that winter. After that we had to wait for chopping time [in the summer]. My brother went back into Childress and played dominoes. That's the way we lived, from what he made playing dominoes.

"We lived in a little two-room house. Had a wood stove that we cooked blackeye peas on. We ate so many blackeye peas that I never wanted to see another one. We even slept on 'em, laid our pallets on the pods of blackeye peas and hay. Your kids would cry for something to eat and you couldn't get it. I just prayed and prayed and prayed all the time that God would take care of us and not let my children starve. All our people left here. They live in California. But we were so poor that we couldn't have went to California or nowhere else."

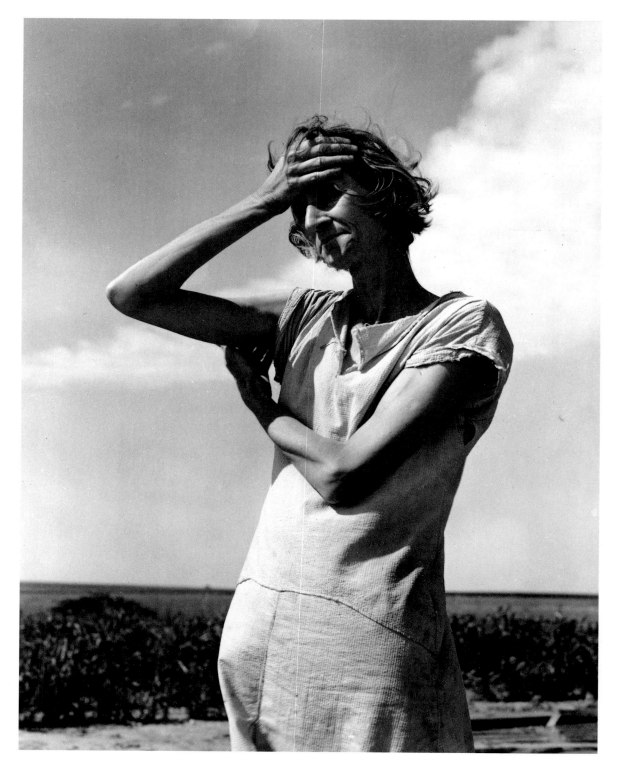

33
Woman of the high plains
[Nettie Featherston]
"If you die, you're
dead—that's all."
Texas Panhandle,
Childress (vicinity)
June 1938
Dorothea Lange

34
Nettie Featherston in
the four-room house she
shares with her son
Lubbock, Texas
August 1979

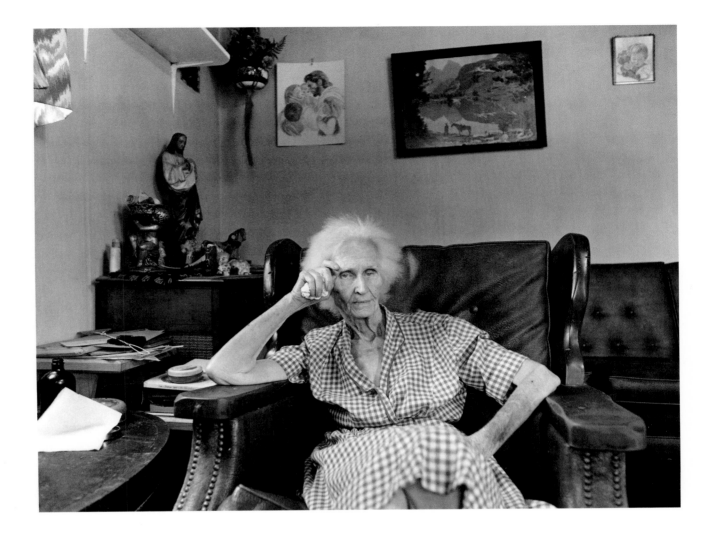

"I never much thought about living this long [eighty-one years]. I just didn't think we'd survive. If you want to know something, we're not living much better now than we did then—as high as everything is.

"I remember those times and it seems like I'm not satisfied. I have too much on my mind. I can just be burdened so bad, awful burdens they'll be. It seems like I have more temptations put on me than anyone, to see if you're able to bear them or not. And every time I ask God to remove this awful burden off my heart, he does."

NETTIE FEATHERSTON

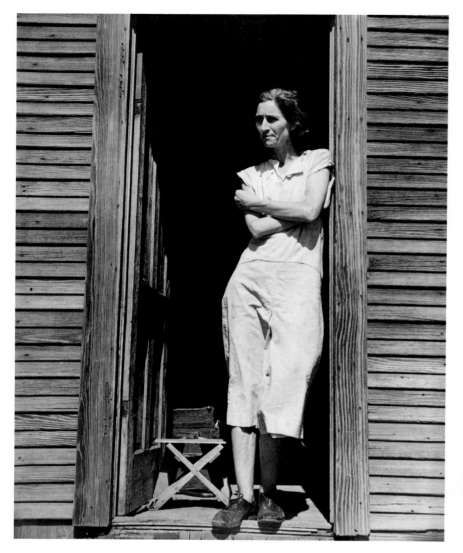

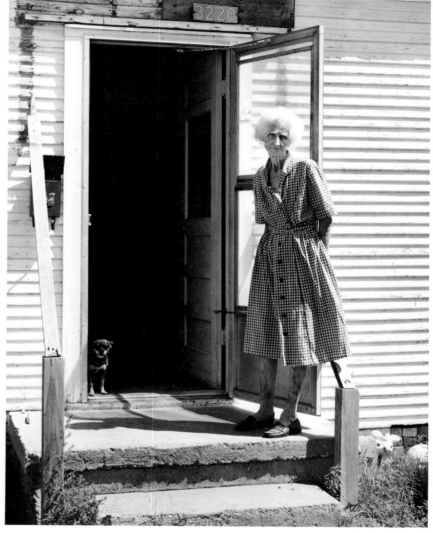

35
Wife of a migratory
laborer [Nettie
Featherston]
with three children
Childress (vicinity),
Texas
June 1938
Dorothea Lange

36
Nettie Featherston
in the door with
her dog, Sandy
Lubbock, Texas
August 1979

The things that uprooted Nettie Featherston's family forced thousands of other families—like those of Florence Thompson, Lois Adolph, and Vernon Evans—onto the road as well. It was this stream of humanity, most often moving west, that Dorothea Lange photographed and economist Paul S. Taylor studied. They called the migration "an American Exodus" and produced a landmark book by that title.

Traveling the same roads from the Great Plains to California and the West Coast, Lange not only photographed these people but recorded in her notebook what they said. Their words give us insight into why they chose to leave the plains and why the West Coast became their destination. Drought, depression, and the mechanization of plains agriculture severely reduced the economic opportunities of tenant farmers on the plains. For many of them, California became a mecca. Years of boosterism by California itself, coupled with overly optimistic reports from migrants who had gone out earlier, created a popular image: California offered a perfect climate and an abundance of work in the state's agricultural industry. There was some work, especially in the new fields of cotton—a crop southern plains people knew all about—but not enough for the estimated 300,000 to 400,000 Okies who went to California over the course of the decade. Instead of immediate riches, they often found the squalor of life in roadside ditch encampments.

37
Billboard along U.S. highway 99, behind which three families of migrants [with fourteen children] are camped.
Kern County, California
November 1938
Dorothea Lange

35

38

Mother and two children on the road.

[From Dorothea Lange's notebook:] Family from Deadwood, South Dakota. On WPA—"till that played out." Been on the road one month with sick baby. Mother says, "What he really *likes* to do is to milk cows. He can do a little of everything, but that's what he likes." Father washed baby's face with edge of blanket dampened, for picture. About to go into the Tulelake migrant camp where there is no pure water, no sanitation, no tent. "Bin trying to get one someway."
Tulelake, Siskiyou County, California
September 1939
Dorothea Lange

39

Oklahoma drought refugee in California. "This is a hard way to serve the Lord. All my folks are in Oklahoma, but I can't feed my kids there."
Imperial Valley, California
March 1937
Dorothea Lange

40

The Farm Security Administration emergency camp for workers in the pea harvest. Farmer from Nebraska in the camp, during pea harvesting. He says, "I put mine in what I thought was the best investment—the good old earth—but we lost on that too. The finance company caught up with us, the mortgage company caught up with us. Managed to lose $12,000 in three years. My boys have no more future than I have, so far as I can see ahead." He had been on the road a little less than a year.
Calipatria, Imperial County, California
February 1939
Dorothea Lange

41

Spanish-speaking woman topping onions, with her son alongside her. Most of the migrants in this area of Colorado are family groups from either Texas or Mexico who work potatoes, sugar beets, cucumbers, carrots, and onions from May to October.
Near Gilcrest, Colorado
October 1979

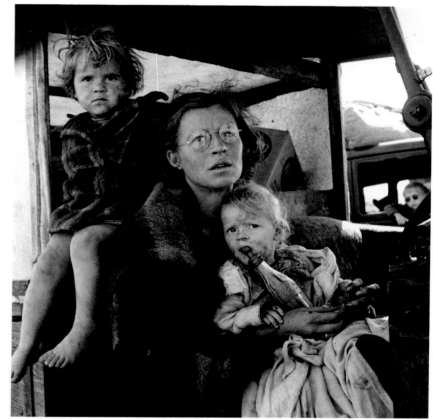

38

39

40

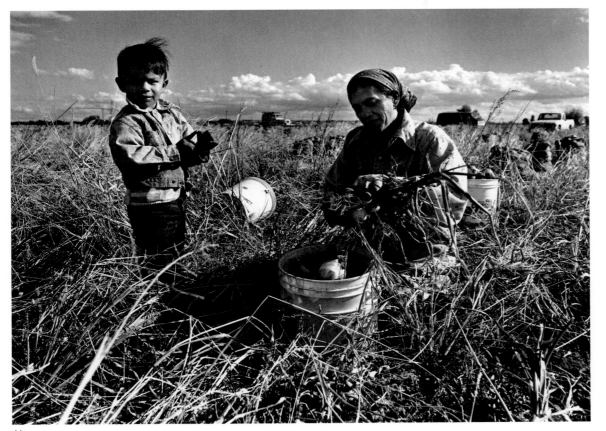

41

This was not the first large-scale migration to California, nor even the largest. In fact, the decades immediately preceding and following the thirties saw larger influxes of people into the state. But the plight of the Okies, dramatized by the work of people like Dorothea Lange and John Steinbeck, came to symbolize the suffering caused by the Depression. They took on an importance far beyond their numbers.

Before the Okie migration, Mexican and Filipino workers and single white men—"bindlestiffs"—had supplied the large farms with the seasonal labor needed to work the crops. These groups often lived in conditions similar to those facing the Okies. But the Okies were different in at least two ways. First, they came in family groups, with children and grandparents, their worldly possessions crammed into the back of a truck or car. This was a fact that Lange

repeatedly documented. And one of their primary goals was to find someplace to settle down. They were not content to spend their lives working for other people in seasonal labor; they wanted a home of their own. Their dreams were those of most Americans.

Second, they were white. As Walter J. Stein has written in *California and the Dust Bowl Migration,*

If this migration of white Americans had not occurred, Mexicans and tramps would have continued to pick the crops in accustomed poverty and misery. No *Grapes of Wrath* would have been written; no migrant problem would have attracted the nation's gaze; no novel, however brilliant, which chronicled the migratory route of the Pedro Morenos in California's valleys could have become a best seller. The tribulations of the Joads received attention, however, because the nation found intolerable for white Americans conditions it considered normal for California Mexicans or Negroes. [P. 215]

Still, the Okies in Lange's photographs, and thousands like them, went through wrenching experiences—so wrenching that it is now difficult or impossible to find the people in Lange's photographs. I tried. Some of them may have died during the thirties. Others were scattered up and down the West Coast, where they may have picked cotton in Shafter, California, and then picked fruit in Yakima, Washington.

The forces that put them on the road have severed their ties with the plains and the past, quite literally displacing them. It is as if they were lost in the migrant stream. Some of them are pictured here.

42
Sugar beet worker
drinking water
Adams County, Colorado
October 1939
Arthur Rothstein

43
Young Spanish-American
sugar beet worker
Adams County, Colorado
October 1939
Arthur Rothstein

44
Field worker with knife
used in topping sugar beets
Adams County, Colorado
October 1939
Arthur Rothstein

45
Migrant worker in the
Ralph Nix Produce
Company packing house.
The Immigration Service in
Colorado estimates that up
to 90 percent of the migrant
workers in this area are
illegal immigrants from
Mexico; even the Colorado
Migrant Council, an
advocacy and assistance
group, says that up to half
of the workers may be here
illegally.
Gilcrest, Colorado
October 1979

46
The onion packing opera-
tion at the Ralph Nix
Produce Company, where
onions are sorted for size
and quality, packed into
fifty-pound sacks, and
stacked on pallets by
migrant workers.
Gilcrest, Colorado
October 1979

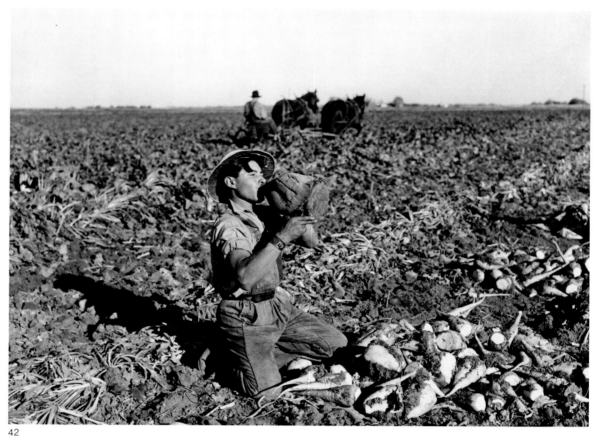

42

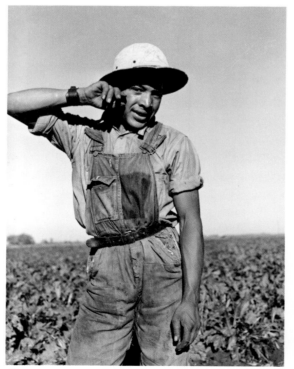

43

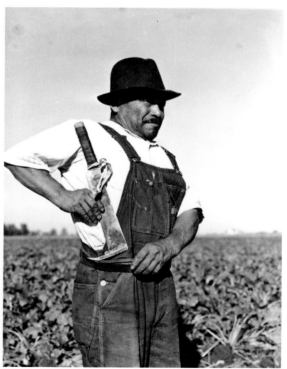

44

When the California defense industries began gearing up for World War II, the Okies began to be assimilated and accepted into the mainstream of the culture. Gradually they were replaced in the fields by Mexican and Mexican-American migratory farm workers. That was also true on the plains, where white migrants settled back down and Spanish-speaking workers took over the work in the fields. The estimated 200,000 migrant farm workers today—whether on the plains or in the interior valleys of California—share common experiences of low pay, poor housing, little or no education for their children, and a declining number of jobs in the face of increasing agricultural mechanization. There is a major difference between the two regions, however. The plains states have not witnessed any of the union organization effort that Cesar Chavez and the United Farm Workers have mounted in California.

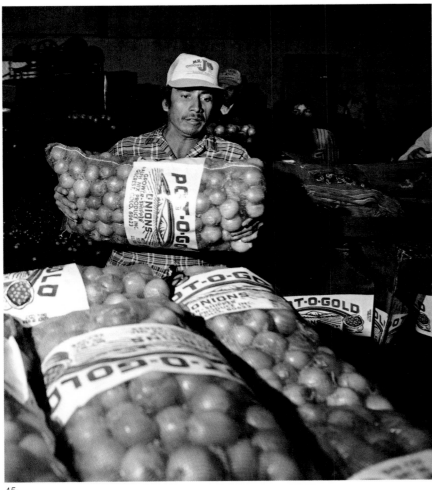

45

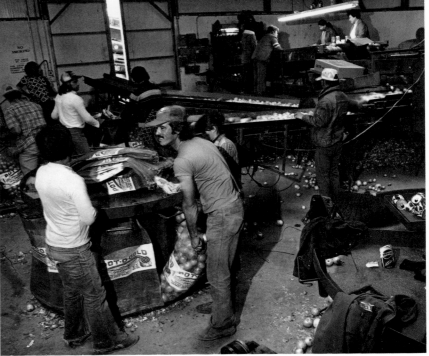

46

47
Fifteen-year-old daughter
of a migrant family of seven
in the bedroom she has
shared with her sisters for
five months. The quonset
hut has five rooms,
including kitchen and bath.
With only handwork left to
be done in the fields, the
family plans to return soon
to Lamesa, Texas.
Platteville, Weld County,
Colorado
October 1979

48
Great Western sugar
company's colony for sugar
beet workers. A girl of six,
who has full charge of her
baby brother, because her
mother "works outside
somewhere."
Hudson [Weld County],
Colorado
September 1938
Allison

49
Daughter of a migrant
family; this day, the girl's
parents were either in the
fields or in Greeley. She
was being cared for by the
older kids in the potato
company's housing.
Platteville, Weld County,
Colorado
October 1979

47

48

49

50
Great Western sugar company's colony for sugar beet workers. "This chicken house we're standing against is the only house here that doesn't leak. It's so low my pop can fix the roof."
Hudson [Weld County], Colorado
September 1938
Allison

51
Migrant children in front of one of the five quonset huts built by the potato company and rented to the migrants for $20 per week. The largest family here has twelve members who live here during the five-month season.
Platteville, Weld County, Colorado
October 1979

50

51

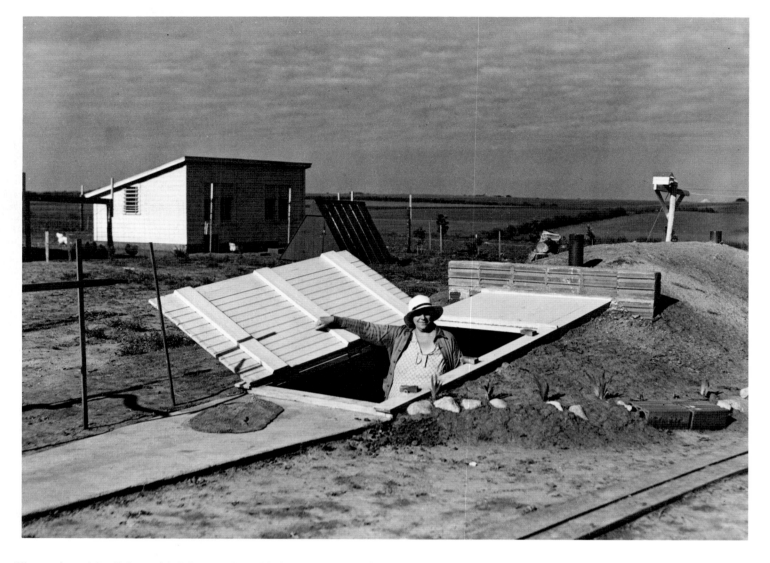

52
Wife of a farmsteader [Mrs.
Harvey Taft]
Falls City Farmsteads,
Nebraska
May 1936
Arthur Rothstein

53
The "cave" on Harvey Taft's
farm. Harvey was one of the
original members of the
FSA-sponsored
cooperative farmsteads
and bought most of the
land and buildings when
the program ended in the
early forties.
North of Falls City,
Nebraska
June 1975

"I've enjoyed it all. I wouldn't have missed it for anything, and I wouldn't want to go through it again. It got to where you couldn't buy a job in the thirties when the Depression hit—got rough. It got to where I was working for a fellow for a dollar a day putting in about fourteen hours a day. He comes to me and wanted to hire me for the season. He said he'd give me $17 a month. He says he could hire a man for that.

"I says, 'Well, you'd better go hire him, because,' I says, 'I can't. Less than a dollar a day, my family can't live. I know, I tried it too long.'

"So he says, 'What will you do?'

"I says, 'I can sign on the relief.' So I did. I got $2.44 a day on relief and a grocery order. Then they built this project here and I was selected for one of the families to move on this farmstead. Ten families moved on this eighty acres and had about seven acres apiece, vegetable farming. We built the caves after we moved here.

"After four years we quit vegetable farming and they organized us into a nonstock co-op. But the other men didn't co-op with me. They wouldn't help me when the hay needed put up, they didn't help shock the grain. I blew up. I says, 'I'm done with this co-op.' But some big shots came here and they wanted to sell me a farm out of this. So I told my wife, I says, 'We'd better just stay right here.' And we stayed.

"I sold out when I was sixty-five, fourteen years ago. I sold out to my son, Cleo, here and just reserved my home. I don't own a thing but my household goods and my automobile. I got everything the way I wanted it when I got old, only that I'm left alone."

HARVEY TAFT

54
[Harvey Taft] using a hand
tractor for cultivation
Falls City Farmsteads,
Nebraska
May 1936
Arthur Rothstein

55
Cleo Taft in front of the
house his father, Harvey,
lived in until his death
Falls City, Nebraska
September 1979

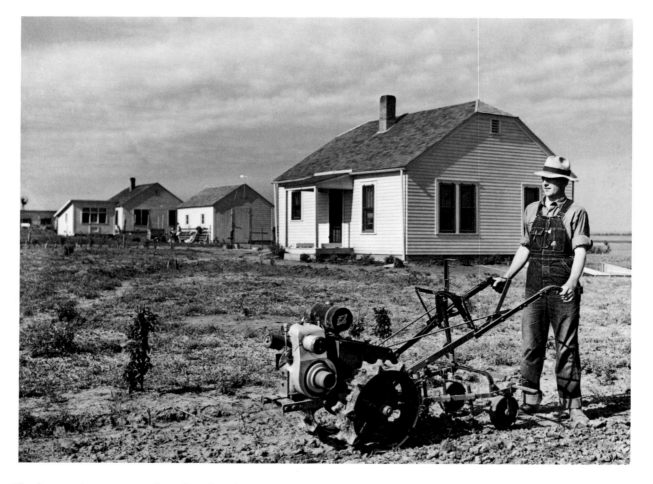

"Dad was always a good worker, hard worker. I
was the only boy and the oldest, so him and I
were always close. Done a lot of hard work
together, and we used to go fishing together,
too.

"I talk to my boys, and they can't realize how
things were back then. We done without a lot of
things, but it seemed like you never com-
plained. Everybody else had the same, you
know. If we had another depression now, it
would be terrible for the younger generation,
'cause they've never had to do without things.
A small child now can spend more in one day
than I used to spend in a week. I don't know
whether they could do [without things] or not. I
hope we never see it."

CLEO TAFT

56
Fritz Fredrick shows how
high his wheat would grow
if there were no drought.
Grant County,
North Dakota
July 1936
Arthur Rothstein

57
Fritz Fredrick in the same
field. Harvest of this wheat
has been delayed by early
summer rains.
Grant County,
North Dakota
July 1977

"This picture here was taken in 1936 and this was practically the only field of wheat that I know of that was harvested. I just picked it up, and I used that for just chicken feed. I picked up two loads out'a about twenty acres.

"We had just shifted in the thirties from horses to tractors. That was a big shift. Those that had horses went down to practically nothing. That was hard done. And then the dust storms come along. The ground got real fine and it would not stop blowing. Some of it drifted up the field where there was some sand drifted so deep that you couldn't even drive over it with a tractor. After a while, we started the strip cropping, and this here would disappear. It didn't blow.

"That combine in the old picture, it was around $1,785. That was the whole thing. The one now, oh, I think they're around from $12,000 to $25,000 for these combines. The prices are not in line, that's all I can see."

FRITZ FREDRICK

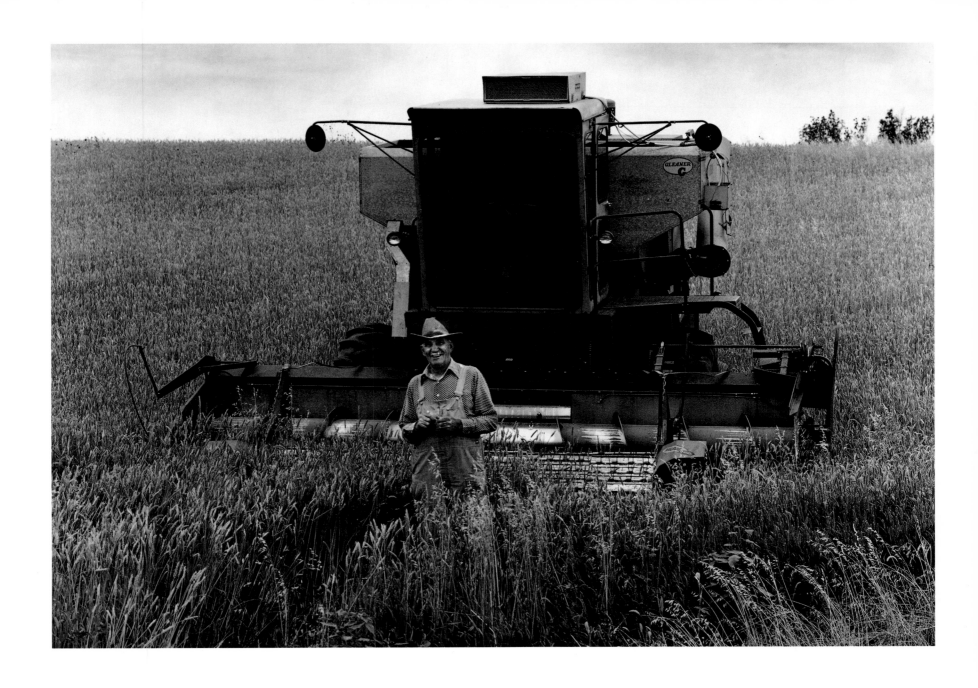

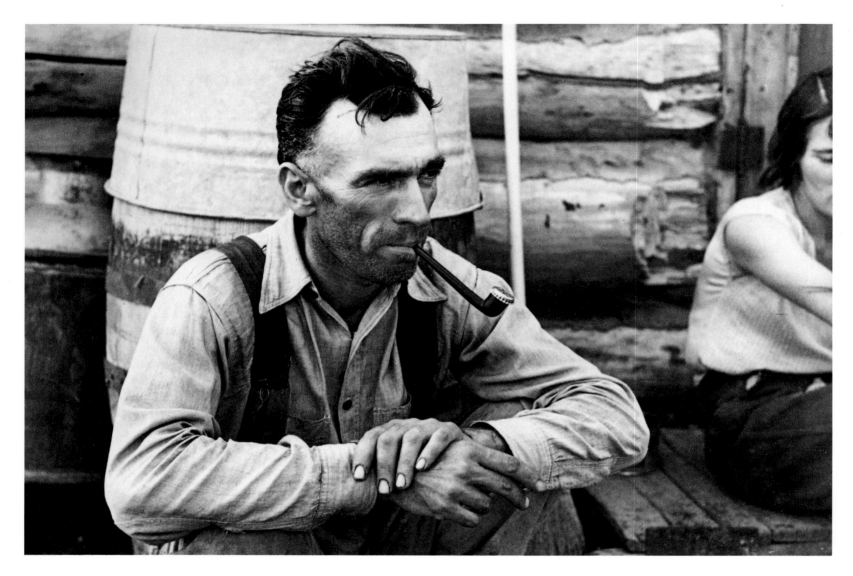

"I been chewing tobacco all my life. I think it preserves the teeth. I never use a toothbrush and I got all my teeth, except one. I could still crack English walnuts with 'em, but my kids told me not to. I used to smoke in them days and I used a bottle cap with small holes in it on the bowl of the pipe. That was for fire prevention, to keep the sparks from jumping out. We had a drought out there. Our chimney—sparks out of it started fires a couple of times, but we got it out.

"I'll put it this way: we just had a plain living. The woman, she'd bake pies once in a while, but that was a luxury. People now live on what I'd say was a luxury them days. The people would get together and they'd have parties, and that didn't cost like it does nowdays. They'd all get together and bring a little to eat, have a little music and dance. Nowdays, to have recreation like we had then, if you hain't got $25 or $30 in your pocket, you better forget about them recreations."

WILLIAM HURAVITCH

58
William Huravitch, farmer
Williams County,
North Dakota
September 1937
Russell Lee

59
William Huravitch in front
of his old house
Williams County,
North Dakota
November 1979

48

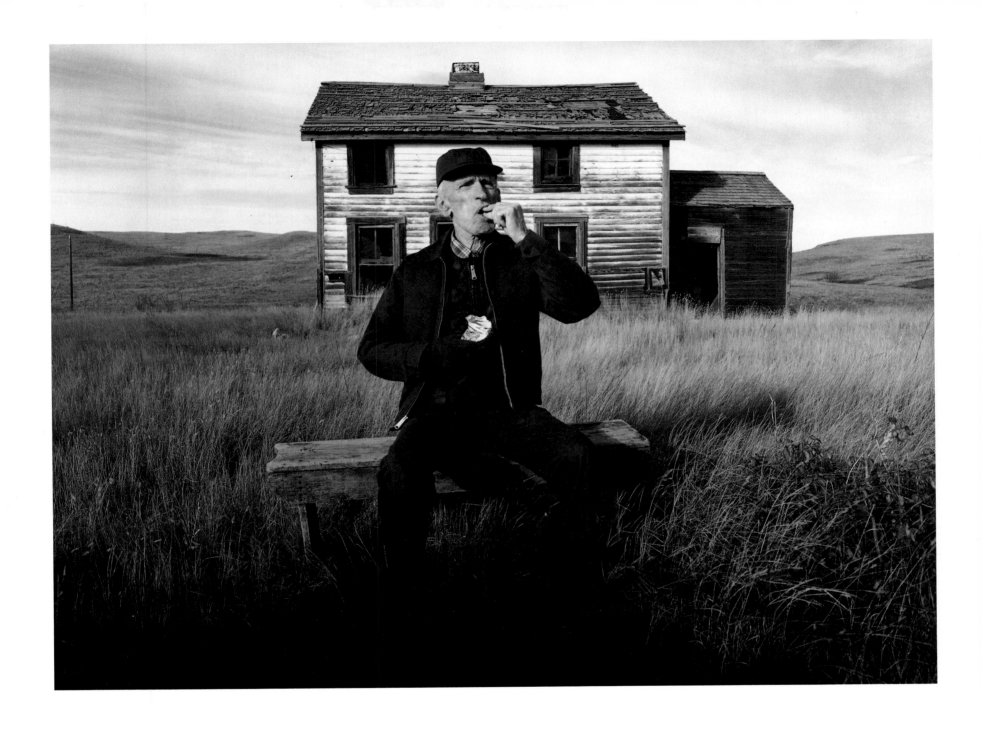

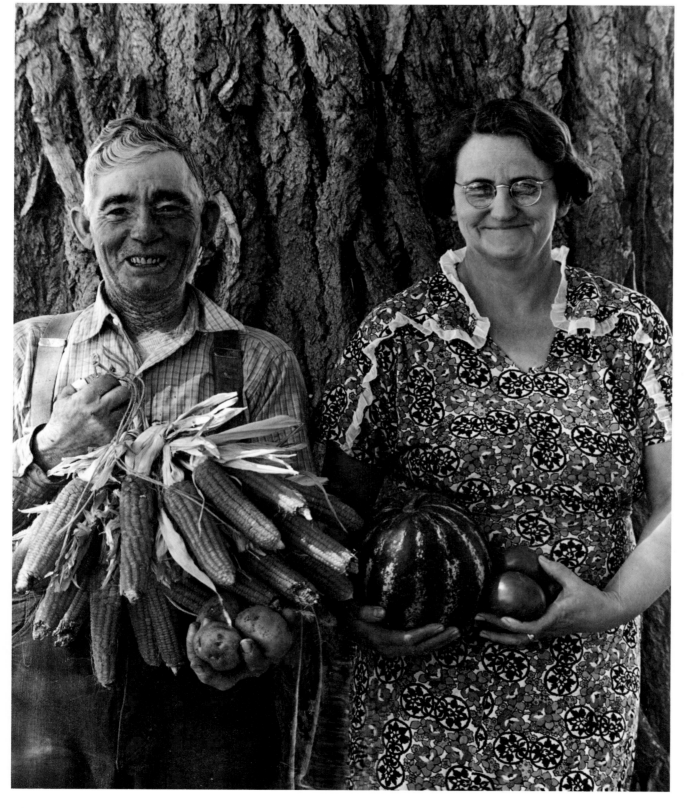

60
Mr. and Mrs. Andy Bihain,
FSA clients
Kersey, Colorado
October 1939
Arthur Rothstein

61
B. D. (Don) Bihain on the
farm that he inherited from
his father, Andy, in 1954.
Don's youngest son
already has a part interest
in the farm, and Don hopes
to be able to pass it on to
him one day.
Kersey, Colorado
During corn harvest,
October 1979

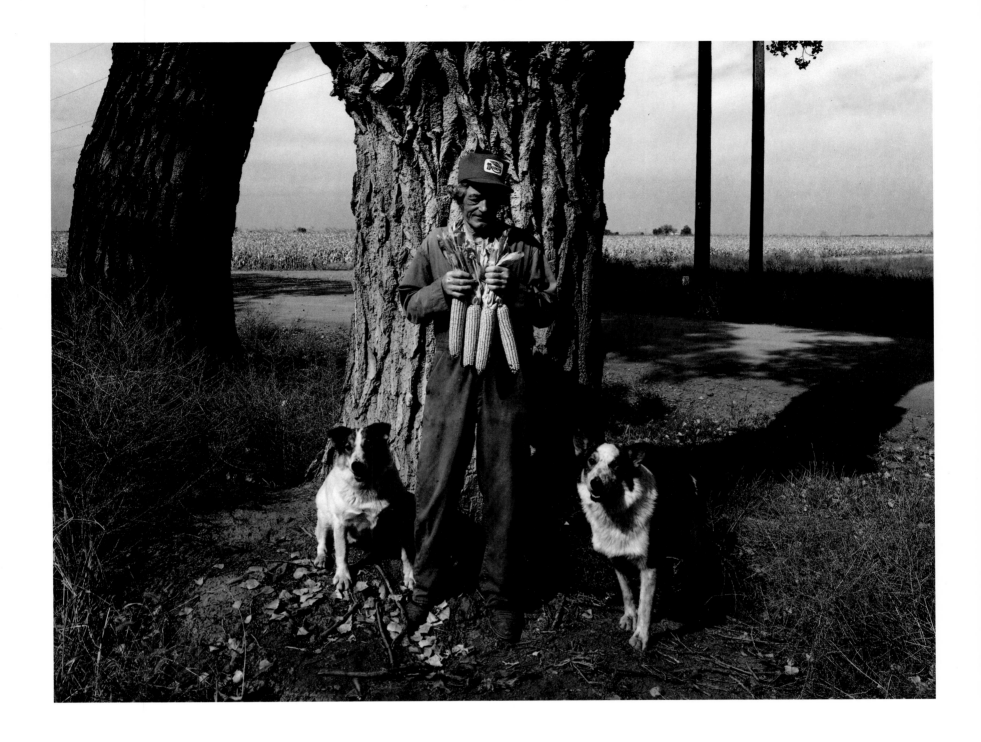

62
Barn on a large farm
Red River Valley
Cass County, North Dakota
November 1938
John Vachon

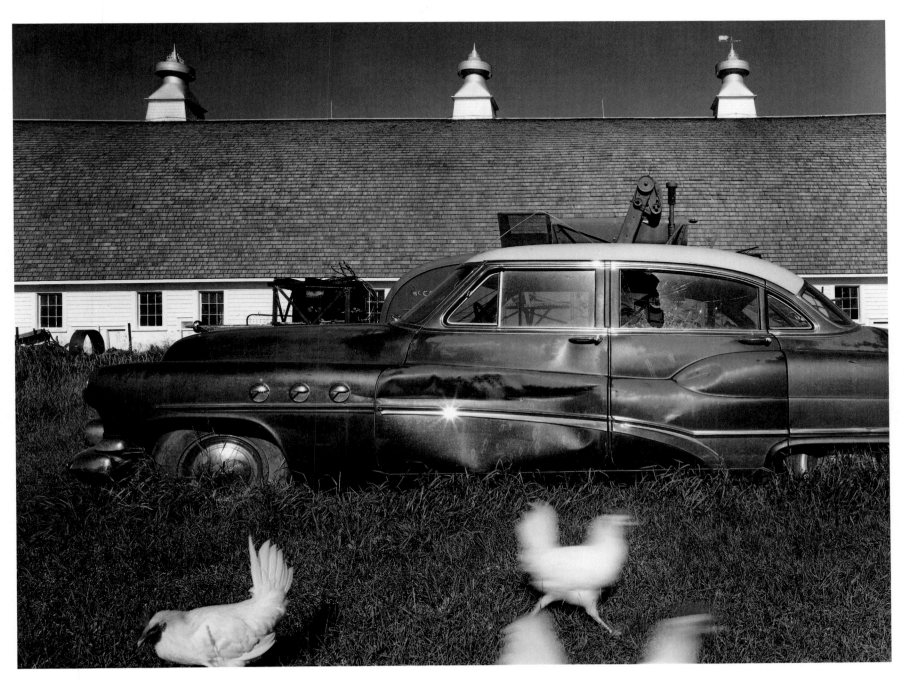

63
Hog barn and chicken on
the Barker farm
Near Gardner,
Red River Valley
Cass County, North Dakota
July 1977

64
Entrance to the mess
hall, Quarter Circle U
Brewster-Arnold Ranch
Near Birney, Montana
June 1939
Arthur Rothstein

65
The mess hall; the bell
is still used to call
people to dinner,
Quarter Circle U Brewster
Ranch
Near Birney, Montana
October 1979

66
Cowhands at dinner during
the roundup [Burton
Brewster in far right
foreground]
Quarter Circle U Brewster-
Arnold Ranch
Near Birney, Montana
June 1939
Arthur Rothstein

67
Burton and Kirtlye Brewster
at lunch, with the postman
who brings their mail
directly to the house in
exchange for a meal
Quarter Circle U Brewster
Ranch
Near Birney, Montana
October 1979

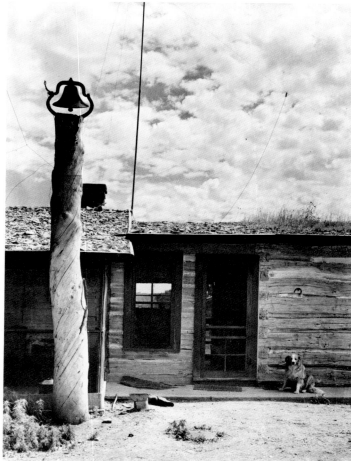

64

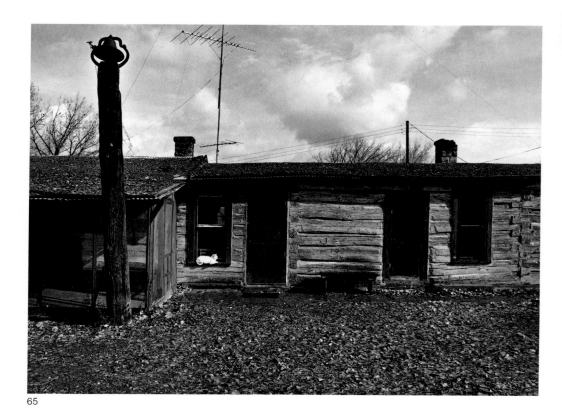

65

"We're direct descendants of the Elder Brewster who came over on the Mayflower. My father came west from Pennsylvania in the early 1870s and worked in the silver mills and mines in Nevada and California. But he always wanted to get in on the last of the buffalo. So he migrated back here in the 1880s, and started up the Tongue River valley with a team and wagon, a saddle horse, and all his worldly belongings. When he came over this hill, there were deer out on the flat and he knew he was in the general vicinity of the buffaloes. So he said, 'I've traveled as far as I'm going to travel.' He took a squatter's right on this land and started building the buildings that are still standing. Built them out of logs squared up with a broadax. He got his buffalo, too.

"All of our land is now leased to coal companies for possible future development. We've got five or six mines within fifty miles of us. The only effect ranching people have felt is in trouble hiring labor because of the high wages the coal companies pay. There's nobody wants to work on a ranch. That's why this ranch now is operated almost entirely by members of the family."

BURTON BREWSTER

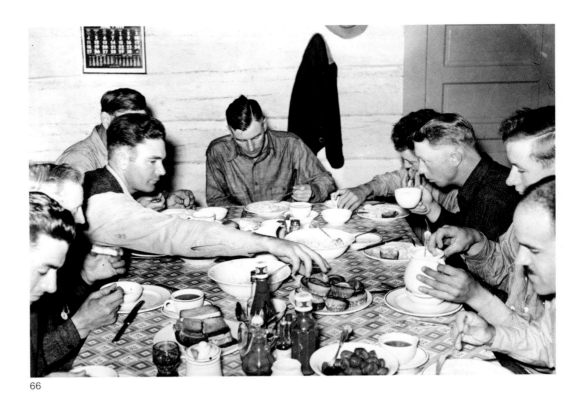
66

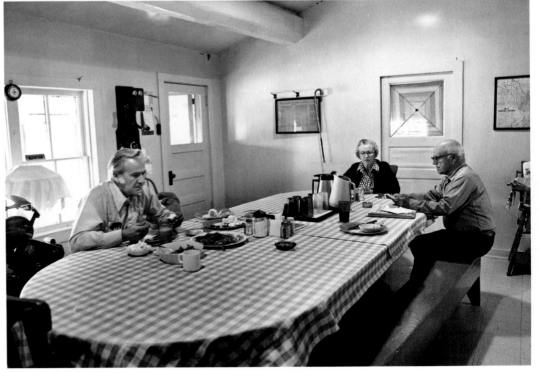
67

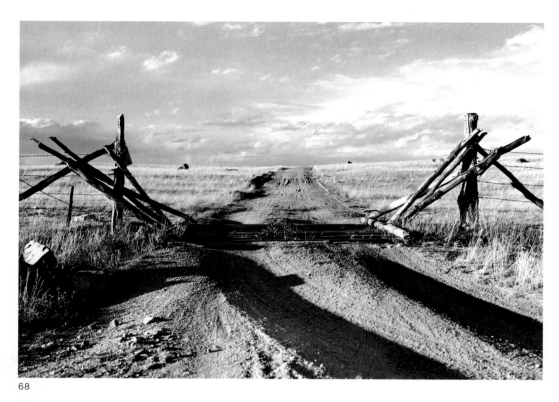

68

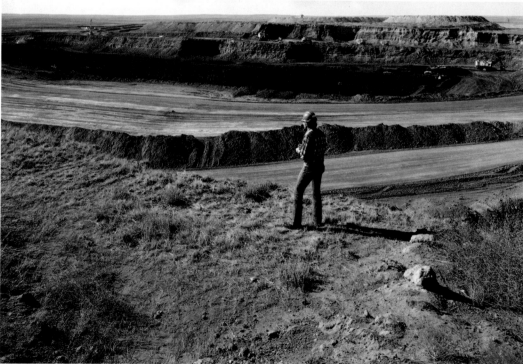

69

68
Cattle gate and grazing
land on a ranch
Burford (vicinity), Wyoming
September 1941
Marion Post Wolcott

69
Ron Bunnell on the rim of
the Black Thunder open-pit
coal mine. Black Thunder
will eventually be the
largest mine in the area,
with seventeen sections of
land under lease.
East Wright, Wyoming
October 1979

70
Chuck Wilson replacing
the teeth on one of the four
electric shovel units at the
Black Thunder mine
East of Wright, Wyoming
October 1979

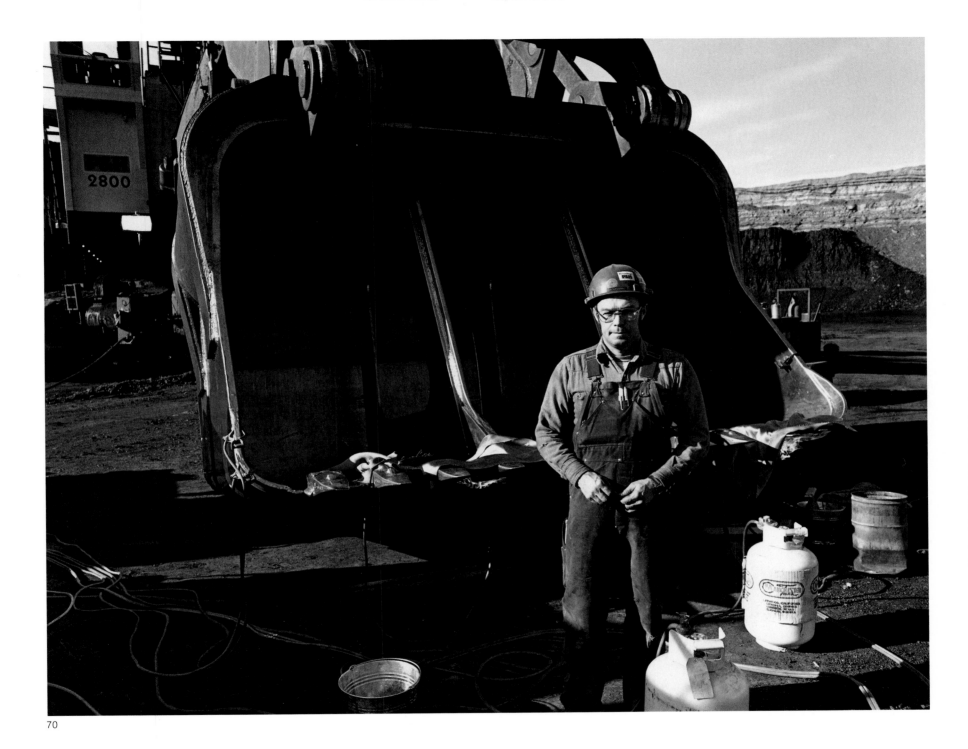

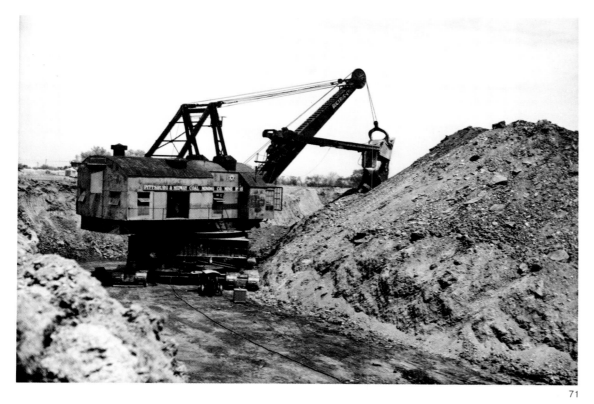

71

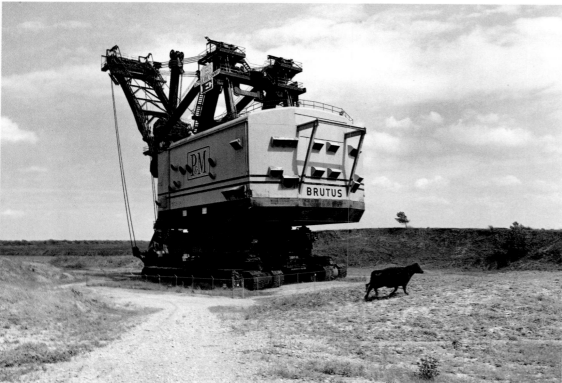

72

71
Strip-mining operations
with 32 cubic yard
steam shovel
Cherokee County, Kansas
May 1936
Arthur Rothstein

72
"Brutus," the abandoned
strip-mining shovel. When
new legislation went into
effect requiring the
reclamation of strip-mined
land, the mines in this area
became unprofitable.
Brutus was parked in the
middle of a field and an
eight-foot fence put up
around it. This area has not
been part of the new
western coal boom.
Near West Mineral,
Cherokee County, Kansas
May 1979

73
Getting the mail at 18
degrees below zero
Morton County,
North Dakota
February 1942
John Vachon

74
Jake Sorensen getting the
mail at 6 degrees below
zero, lowest in the nation
that day. Jake and his son
and daughter-in-law rent a
house and mobile home
about a mile down the lane
in the background, in the
middle of a 2,000-acre
ranch. They keep the lane
clear with a four-wheel-
drive truck and snow blade.
Morton County,
North Dakota
March 1979

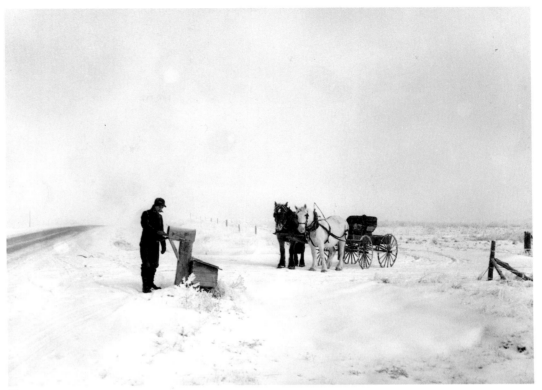

73

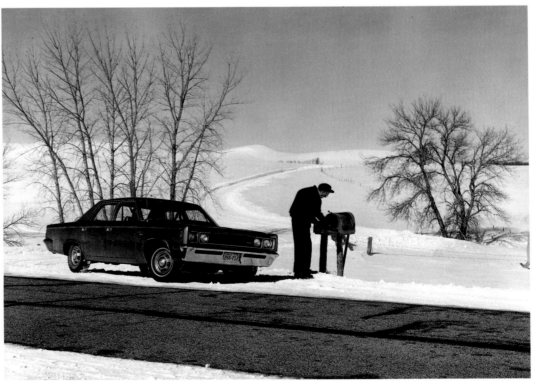

74

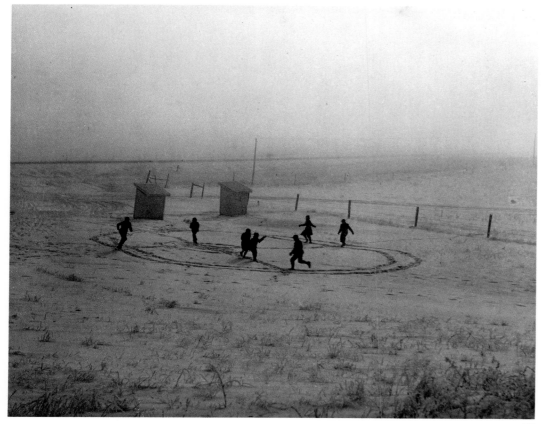

75

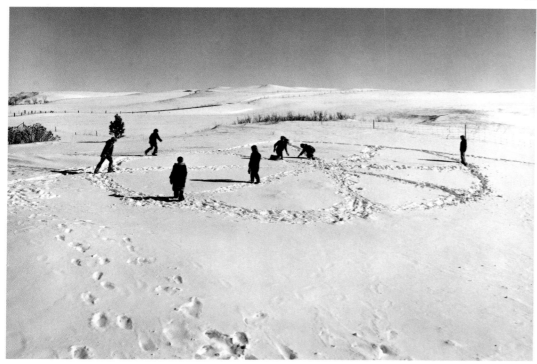

76

"I was on the school board in 1966 when the school was closed and the district joined Raymond Central Public School. We moved the building up here to our place in the fall of '67 or the spring of '68.

"I think it's a much better education for the youngsters now, a lot more chances to learn more different things than they get in a country school, although the country schools were good and served their purposes. If they had a good teacher, why, they were a good school. My family moved around a lot when I was a youngster, and when you went to a new school, you almost could count on a fight the first day or the second day. They didn't care too much for strangers, but after that was over with, then you got along all right.

"We just use the building to store a little hay and straw in is all now."

TED CHRISTENSEN

75
Playing "cut the pie," or "fox and geese," at noon recess at a rural school
Morton County,
North Dakota
February 1942
John Vachon

76
Teacher and students playing "fox and geese" at morning recess. Sweetbriar rural school district
Morton County,
North Dakota
March 1979

77
One-room school. Nebraska's school system is very little consolidated; these little schools are on county crossroads throughout the state.
Lancaster County,
Nebraska
October 1942
John Vachon

78
One-room schoolhouse, formerly district no. 112, on the Ted Christensen farm a quarter mile from its original site
Lancaster County,
Nebraska
May 1976

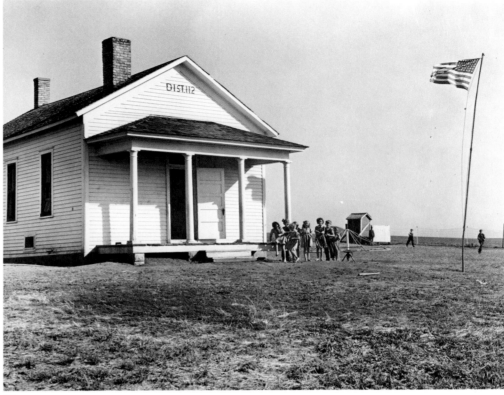

77

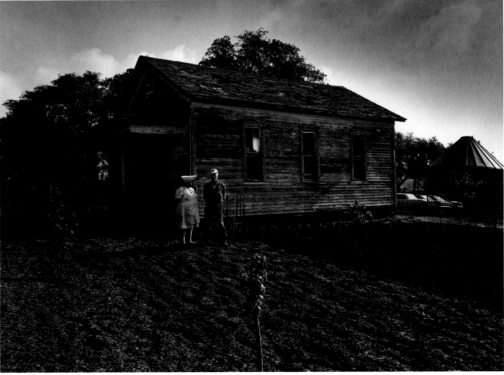

78

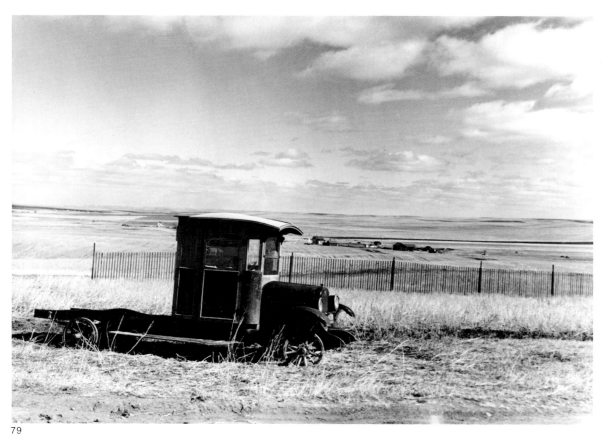

79

79
Dryland farm
McCone County, Montana
March 1942
John Vachon

80
'50 Chevy with a straight six
on the Edwin and Leander
Schumacher dryland farm
Circle, McCone County,
Montana
October 1979

81
Old type tractor used
during the wheat boom
Brockway, Montana
March 1942
John Vachon

82
International Elevator
Company. The elevator has
had only eight railroad cars
this month. Thirty or more
are needed to move the
stored wheat to market.
Brockway, Montana
October 1979

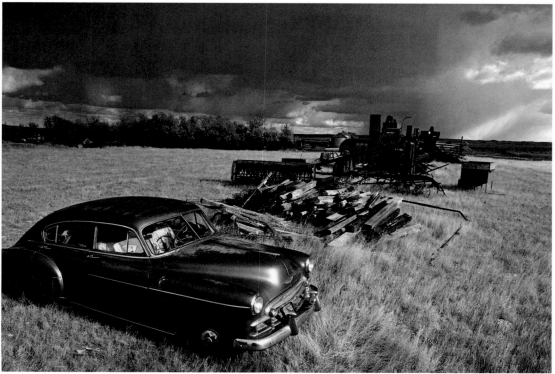

80

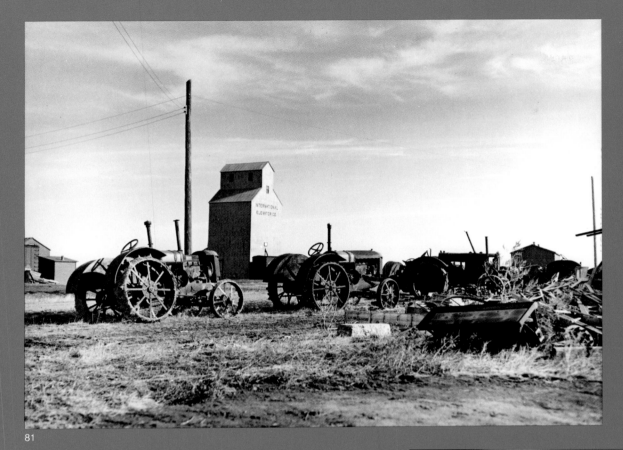

81

"The Great Plains area has just enough towns to wait upon the country and the railroads. The first towns here, sometimes called 'Hells on Wheels,' were those interesting collections of technical skill, transient labor and floating vice that make up the construction camp of a frontier railroad.... Today the chief town population within this region is at the places where railroads change crews and repair their equipment."

From J. RUSSELL SMITH, *North America*

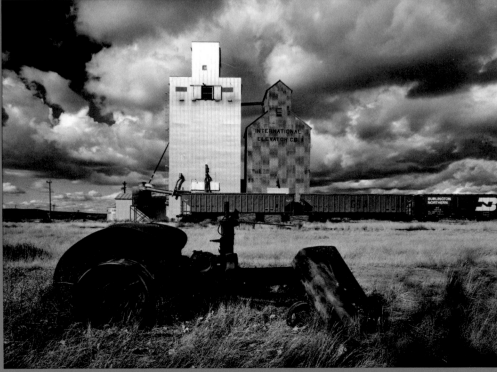

82

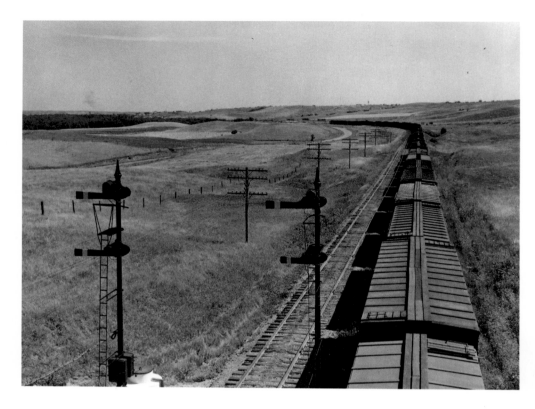

83
Freight train going west
Minot, North Dakota
August 1941
Marion Post Wolcott

84
Freight train going east
Minot, North Dakota
July 1978

85
Grain elevators
Omaha, Nebraska
November 1938

86
Grain elevators
Near Axtell, Nebraska
June 1978

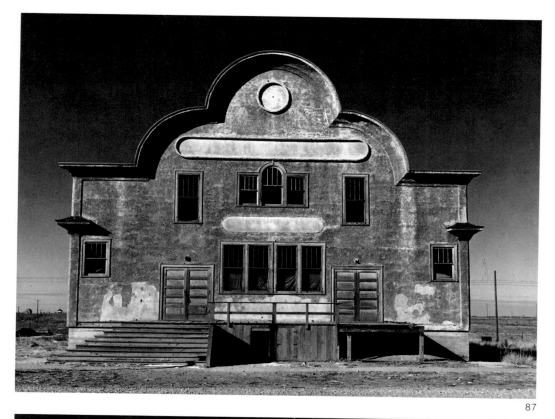

87

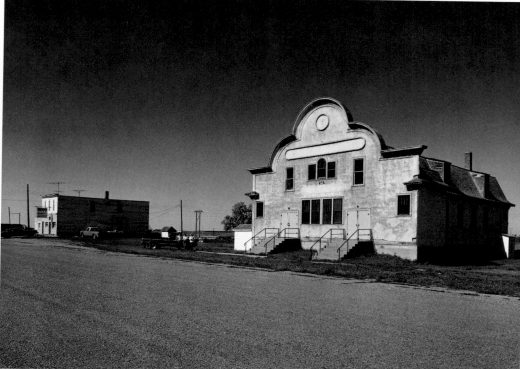

88

Jim Haider: "Our little hall here is still used. It's got a couple of good uses, I think. Wedding dances, that's the one I get a charge out of. They draw between 300 and 500 people. It's one big drunk, that's about what it is."

Is there much to do around here?

Rob Severance: "In this town? Well, go out hunting gophers. [Laughter.] And drink beer, and have a good time, which is what we're doing right now. I don't know, it's just a small community."

John Haider: "It's real quiet, not too much ever happens around here. It's simple, I guess, that's what I call it."

Do you like that?

John: "Oh, not really. I've gotten used to a little more fast-life, I guess. I don't like it too much here any more.

Rob: "I'd like to be closer to a city. I don't want to live in a city, but just be closer to a city. I'd say this is a pretty good town for older people, you know, to retire and move to a little town like this."

How many people are there in Zell?

John: "Oh, sixty, right around there. If it wasn't for the two bars, I think it'd probably close up."

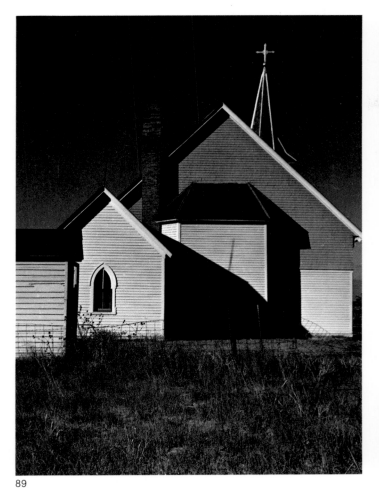

89

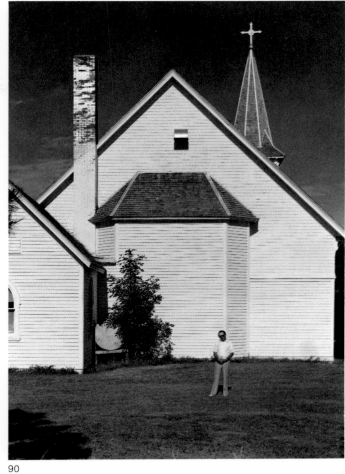

90

87
Community Hall
Zell, South Dakota
February 1942
John Vachon

88
Community Hall
Zell, South Dakota
July 1977

89
Church buildings
Zell, South Dakota
February 1942
John Vachon

90
The lector for early
morning services at St.
Mary's Catholic Church
Zell, South Dakota
July 1978

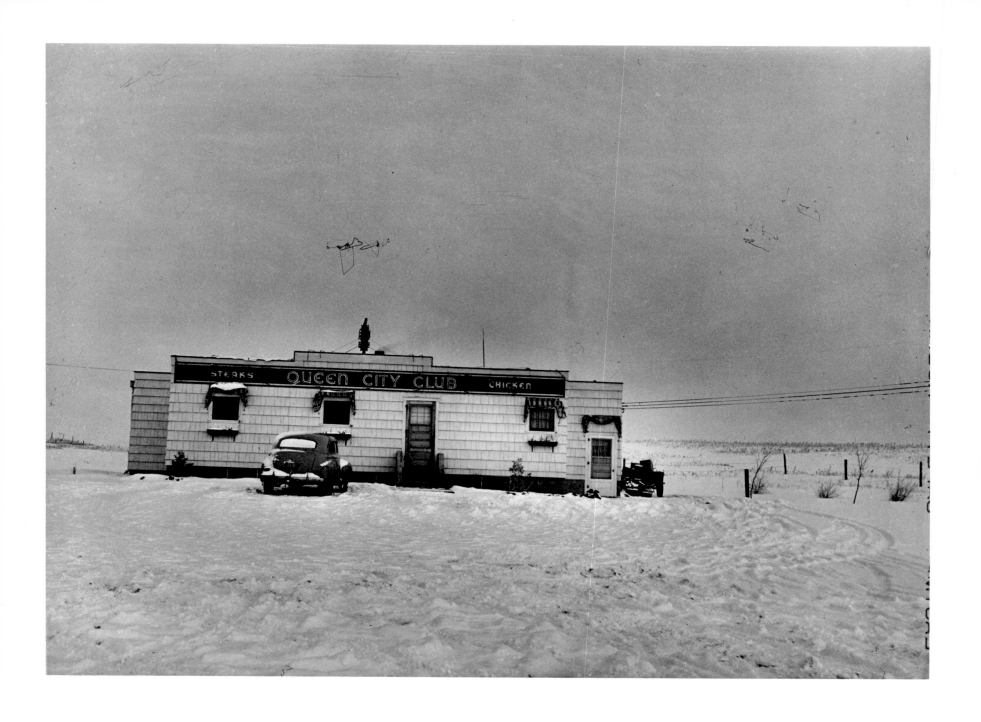

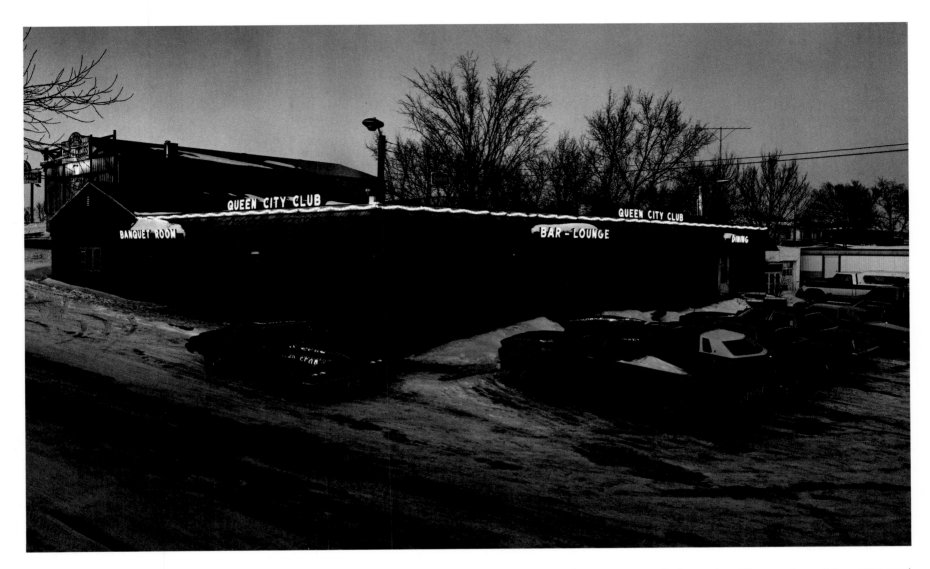

91
Roadhouse
Dickinson (vicinity),
North Dakota
February 1942
John Vachon

92
The Queen City Club early
on a Saturday night.
Dickinson, North Dakota
March 1979

"Since I've taken over the club, I've talked to many people who said that they used to come out here back when they were young kids sneaking into bars. They used to come and court, and then later they had a hall out back here and they'd have weddings back there.

"Right now, I run music every night, whereas before they would have a live band only for special functions. It gets to be a hopping place. I got a lot of good regulars; they're working people throughout the week, and they stop and visit. Then on the weekends, the husband and wife come out and they'll have dinner and spend the evening. I get people here from a fifty-mile radius—out here that's not that much. What's fifty miles?"

ESLEY E. PRIBYL, owner of the Queen City Club

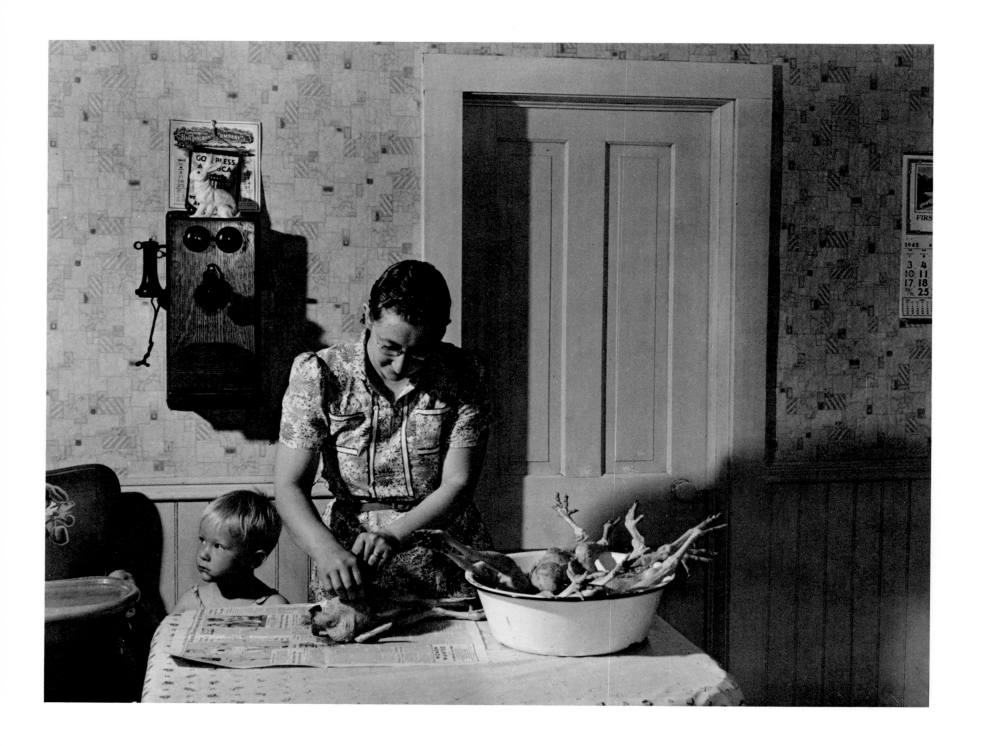

93
Cleaning a chicken,
Mrs. Lynn [Madge] May
Lancaster County,
Nebraska
May 1942
John Vachon

94
Madge May, head book-
keeper, in a display window
of Hovland-Swanson
Lincoln, Nebraska
January 1978

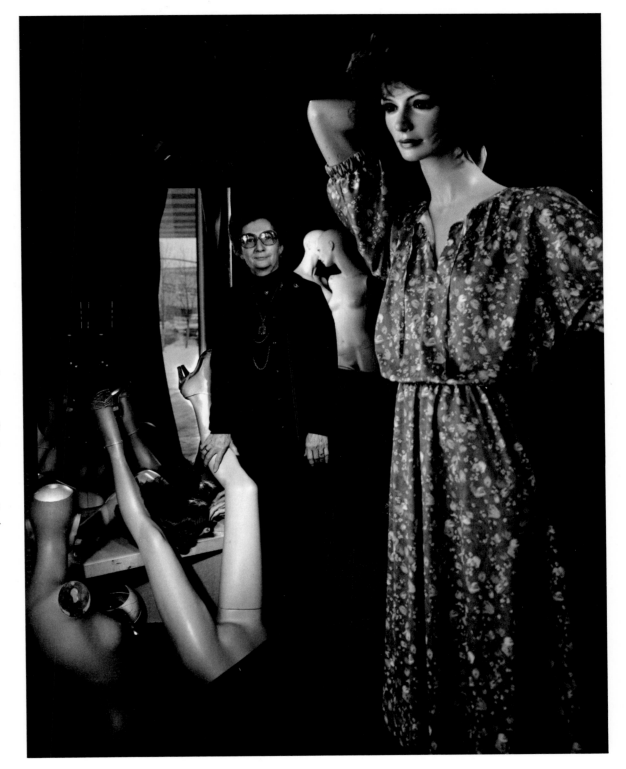

"This must have been about thirty-seven years ago. I don't exactly remember the actual occasion, but I do remember doing that same job many, many times. We used to raise a lot of chickens and I used to clean a lot of them. We cleaned and took them into town for people to use as fryers, dollar and a half a chicken.

"From the farm, we started a Purina feed franchise here in town [Hickman]. We had that five years and then decided that it wasn't *that* prosperous and a lot of hard work, too. So, he sold that and bought a propane gas delivery business. And I decided then to go to work in Lincoln. I went to work at Hovland-Swanson's in January 1953, and I'm still there. Hovland's is an exclusive specialty store, and I'm the head bookkeeper now."

MADGE MAY

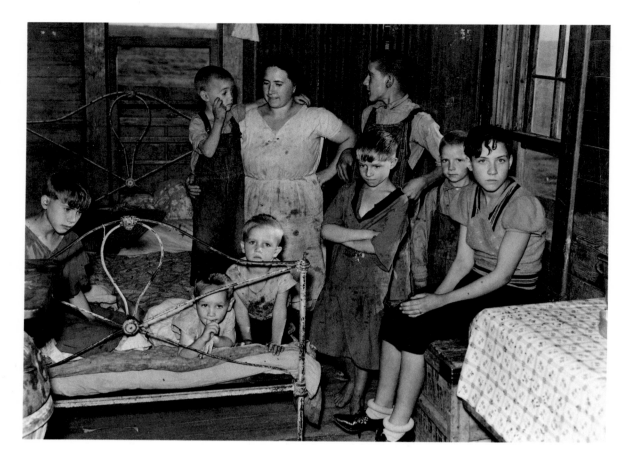

"I was married to George Eoas first. He died in 1929. I had four children and one on the way. Then I married Floyd Peacher and we had three children together. We lived out on the farm. We had those wind storms. You couldn't plant anything; grain would blow right out of the ground. Russian thistles, that's all the cattle had to eat. The government was giving us straw, and they bought up all our cattle and left us with a cow or two so we would have milk. And one year the government gave us wood for winter.

"Peacher died in 1940. I and the kids moved into Williston then. I didn't want to live out there alone. They had 'mother's aid' then. I got so much a month to buy groceries with, and they paid the rent on the house and the fuel. But it wasn't long between marriages that time because I was all alone and needed somebody to help with the kids. So I married Gus Melland, and we had four kids.

"Now they've all moved away but his [Gus's] one son. We live on railroad benefits, he gets $260-some and I get $124 a month. We get $17 worth of food stamps, too."

CLARA MELLAND

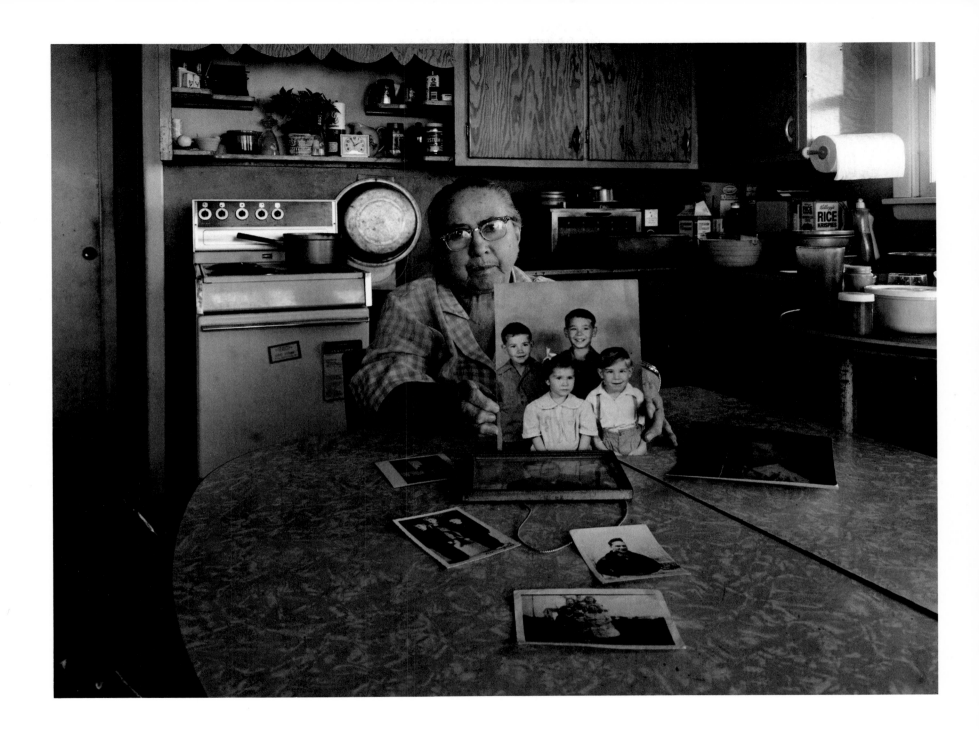

97
Child [John] of Frank Weeks,
WPA worker
Williston (vicinity),
North Dakota
August 1937
Russell Lee

98
John W. Weeks in his
insurance office
Williston, North Dakota
November 1979

"When that picture was taken we were renting a farm place, and there was I and nine other brothers and sisters all at home. Pretty poor family. Times were hard. Our neighbors, if you would happen to be eating there, they'd always ask, 'Is there anything else you want?' And a common reply would be, 'Nothing.' It was commonplace for them to say, 'Well, you'll have to go down to the Weekses' to get that.' I'm forty-three now and I've yet to own my first bicycle. Any kid, you look at your peers and you want what they have. Fortunately, at that time nobody had anything.

"I left home when I was about fourteen and that was the last I was at home on the farm. I never accepted any welfare, any help. I went out and worked and about every three years I'd change jobs, looking for something a little better. Three years ago I went to work with American Family Insurance, and I've done very well with that. All of my brothers and sisters are doing very well, too."

JOHN W. WEEKS

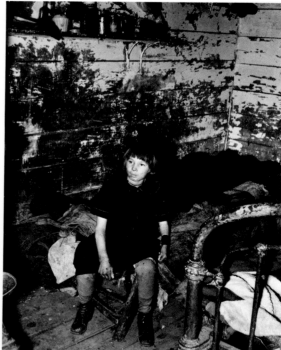

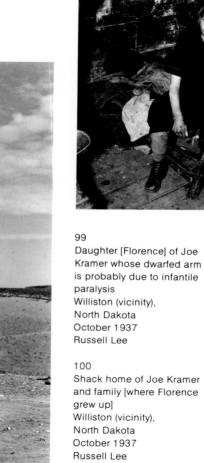

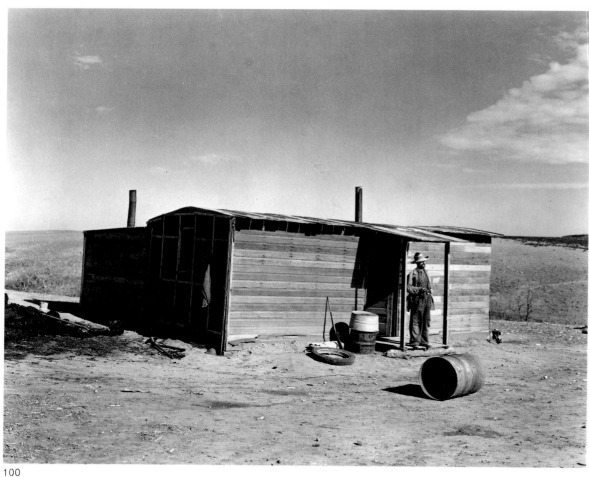

100

99
Daughter [Florence] of Joe
Kramer whose dwarfed arm
is probably due to infantile
paralysis
Williston (vicinity),
North Dakota
October 1937
Russell Lee

100
Shack home of Joe Kramer
and family [where Florence
grew up]
Williston (vicinity),
North Dakota
October 1937
Russell Lee

101
Florence Kramer. Her left
arm was damaged by polio
at the age of two, and she
now walks with a cane.
She has never been able to
work and has lived for
eleven years in a small room
at the S&L Hotel.
Once a week a maid cleans
her room. Meals are served
in a communal dining room.
Williston, North Dakota
November 1979

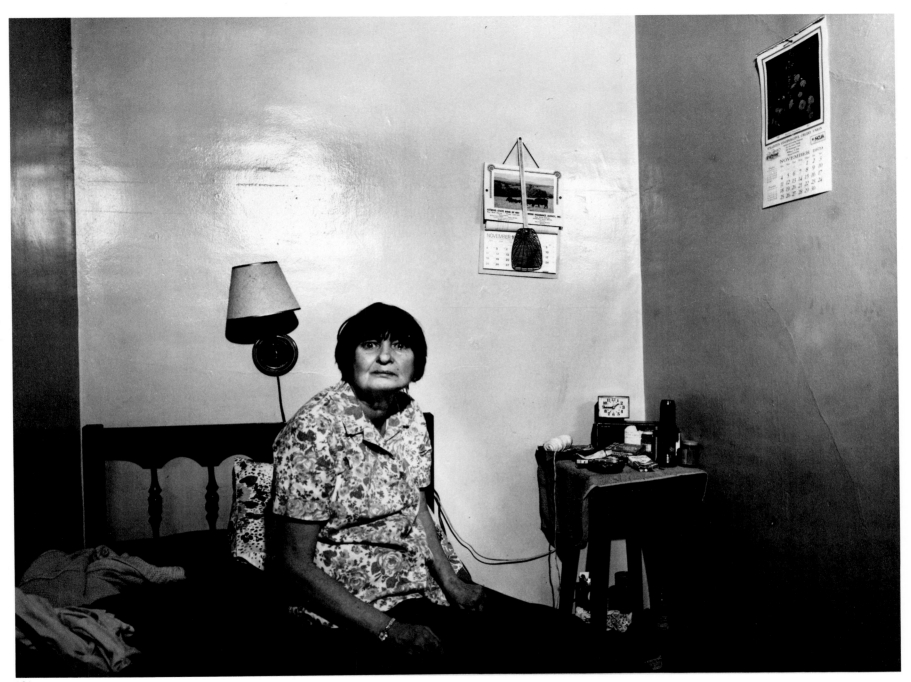

101

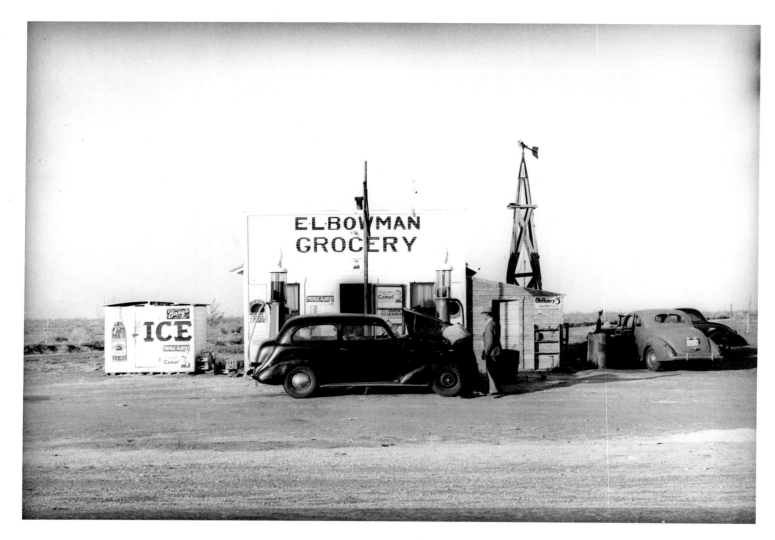

102
Grocery store and filling
station in the High Plains
Dawson County, Texas
March 1940
Russell Lee

103
E. L. Bowman buying gas
at a 7-Eleven grocery and
filling station
Lamesa, Dawson County,
Texas
March 1979

"I moved here from Oklahoma in '36, and that's when we started the little store over there. My twin brother and I, we made three complete [crop] failures up there in Oklahoma, so we come here. We pulled cotton by hand that fall, and then we put in that store late in '36.

"They made good crops here in '37. These Spanish people come from South Texas to pick this cotton by hand, and they'd buy the groceries out there at our little store. It was definitely easier to make a living than it was in Oklahoma. It still wasn't what you'd call easy. My daddy would get up at 4:00 every morning to open the store. He done that all his life. And then we'd close about 9:30 or 10:00 at night.

"We run it until '44. Course I left this country and went to war. When I come back from the army, I went back to farming. Most all the farming was done by hand then. Now it's all mechanized. Now there's not near as many migrant workers as they was back when I first come to this country."

E. L. BOWMAN

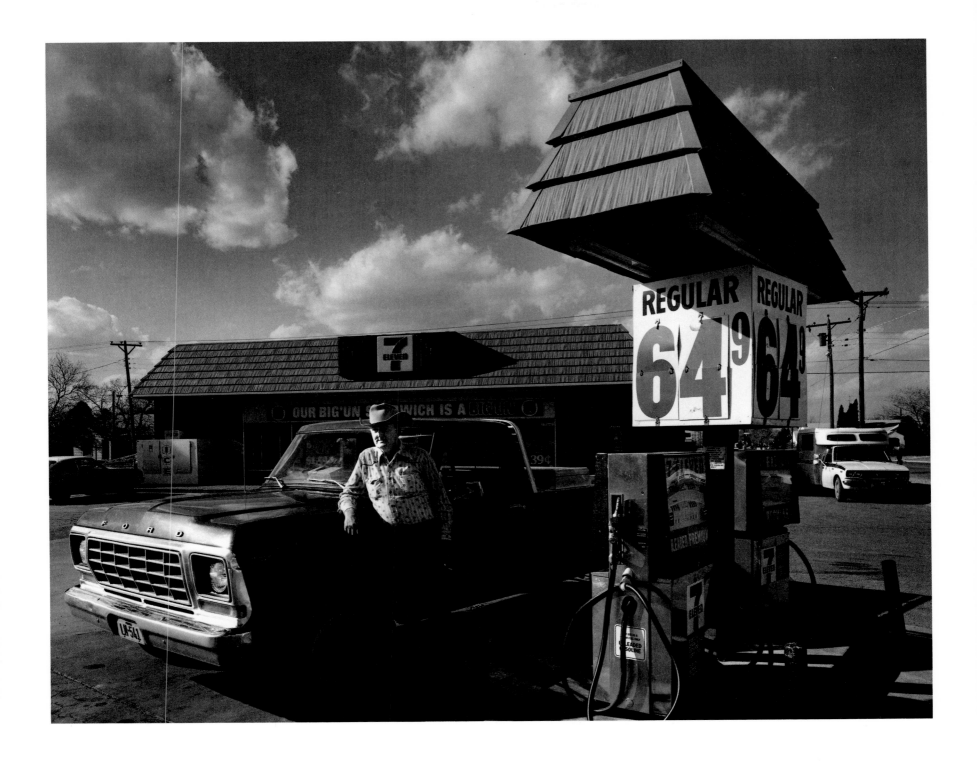

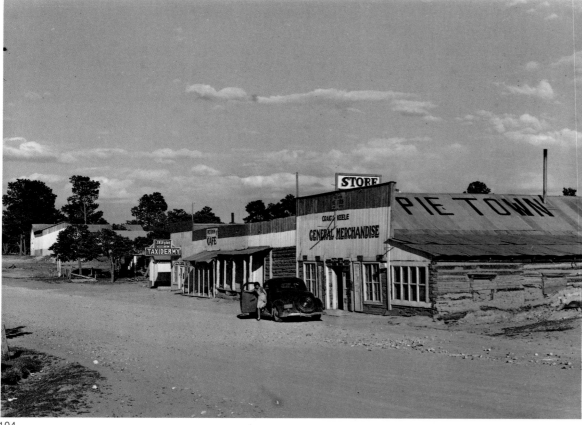

104

105

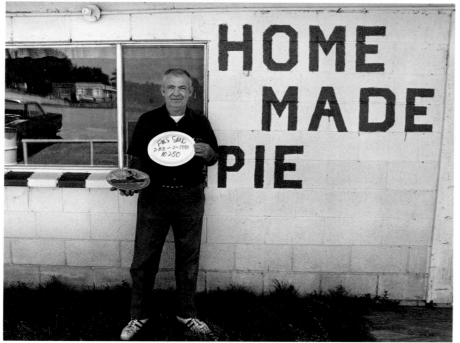

106

104
A community settled by about 200 migrant Texas and Oklahoma farmers who filed homestead claims. Business section.
Pie Town, New Mexico
June 1940
Russell Lee

105
Lois Stagg, who, with her husband, rents and runs the cafe
Pie Town, New Mexico
June 1940
Russell Lee

106
Lester Jackson, who retired from the Marines and opened the Break 21 Cafe in Pie Town; he is justifiably proud of the pies he makes from scratch.
Pie Town, New Mexico
October 1980

107
Stage in front of the post office. This stage comes through daily with the exception of Sundays.
Pie Town, New Mexico
June 1940
Russell Lee

108
Ruth Winkler, mail-bus driver, picking up mail in Pie Town. Ruth makes the run from Springerville, Arizona, to Socorro, New Mexico (160 miles), traveling east one day and back west the next. She stops at each little town to pick up mail, freight, and passengers.
Pie Town, New Mexico
October 1980

"I am a photographer hired by a democratic government to take pictures of its land and its people. The idea is to show New York to Texans and Texas to New York. . . . The idea is even a lot more than that. As the name of our outfit indicates, the Historical Section is accumulating a file of pictures which may endure to help the people of tomorrow understand the people of today, so they can carry on more intelligently.

"When I took my camera to Pie Town, New Mexico, these ideas were in the back of my head. Like every community in this country, Pie Town was unique. It happens also that Pie Town was unique in more than the usual number of ways. Outstandingly, it was unique because it is a frontier town very much after the pattern of frontier towns a hundred years ago. . . . In Pie Town we could apply a twentieth century camera to a situation more nearly typical of the eighteenth century. We could picture the frontier which has unalterably molded the American character and make frontier life vivid and understandable.

"To the people of Pie Town I said with exact truth, 'I want to show the rest of the country how you live.' "

RUSSELL LEE, photographer (in *U.S. Camera,* October 1941)

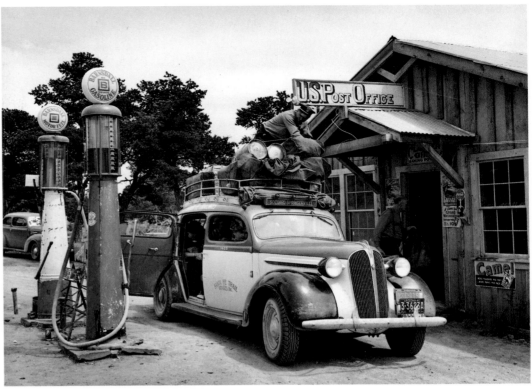

107

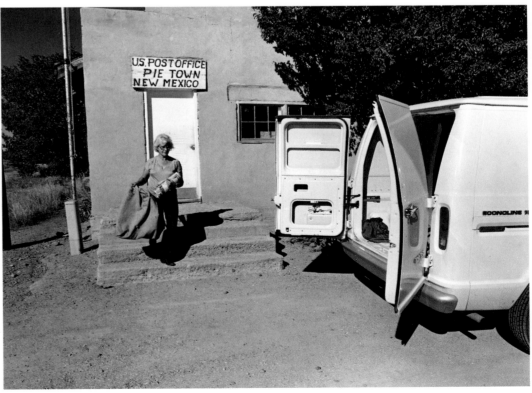

108

"A lot of the people in Pie Town came from the same area, mostly from the dust bowl. The panhandle of Texas and Oklahoma and eastern New Mexico, that area there that blew away practically. We contributed to the let down of the area just as much as anybody else. We came and broke up the land. When we came there it was knee-high in waving grass. These farmers plowed it up and grew wheat. I guess they didn't know how to control these winds, so it blew away our farms practically. There was no way to fight it. You just go along with the elements when they get out of hand that way.

"When we first moved to the plains, to Dimmit, Texas, we were pretty well off. We brought money to the plains and invested in farm machinery—right about the time the Depression hit. Nobody knew this was going to happen the way it did. It just wiped us out. We had bought all that stuff. Some of it was mortgaged, and what wasn't had to be sold to help pay the ones that were. And so, our several thousand dollars we came to the plains with went down the drain. Daddy came out here to Pie Town, and found one place that could be homesteaded. We came in March, 1933. We had all our property on one ole 1928 Chevy truck. When we got to Pie Town we had six cents left after we bought a loaf of bread and paid for our little room for the night.

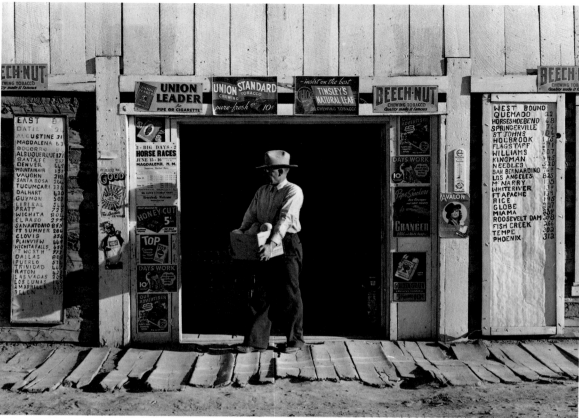

109

110

"My Dad went into the store there working for Mr. Craig, I believe it was 1935. He was partners with Mr. Craig to start with and then he bought him out and built a new store. All I ever worked in the store was just one summer. I think I was seventeen at the time. It was interesting to me. Pie Town was interesting to me, until I got out into the world and realized there was so much more. And then I became discontent and wanted to get out into the world again. So, I took off and wandered around the world a lot. But Pie Town was just part of my life—it *was* my life at the time—more so than it's ever been since."

JACK KEELE

"The old Keele store just had a little of everything in there. They had feed, seed, a few clothes, and hardware. Stuff that people needed. About all the groceries that anybody needed. They just didn't nobody go to town then. If you needed something, you just put your order in there at the store and the next time they got their shipment they just ordered it out."

Do you remember the Depression?

"Well, I thought we'd always been in one, really. *Still* in one. [Laughs.] Well, depression's supposed to be when it's hard to make it. Well, it still is, if you're not careful. There's a job anywhere you want it now, and I guess *then* there wasn't any jobs. But now you can make lots of money and it ain't worth nothing. Back then if you could make a few dollars, well, it would buy something. So, basically we're in the same thing, but it's just different."

POP McKEE

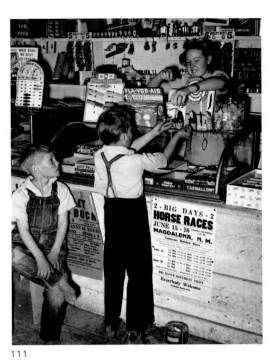

111

109
Mr. Keele, merchant and president of the Farm Bureau, in front of the general store
Pie Town, New Mexico
June 1940
Russell Lee

110
Jack Keele beside the mileage board of his father's old store
Pie Town, New Mexico
October 1980

111
Farm children [Pop McKee, center, with "one of them Leatherman boys"] buying candy at the general store
Pie Town, New Mexico
June 1940
Russell Lee

112
Pop McKee getting his morning coffee from Lester Jackson at the
Break 21 Cafe
Pie Town, New Mexico
October 1980

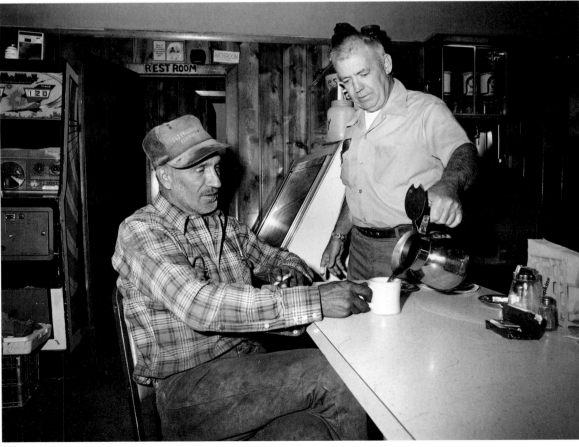

112

Why did your family leave Oklahoma?

"One thing, we was on eighty acres, and that was all we could get. We couldn't expand, and the place wasn't big enough to make too much money. And mother's health wasn't too good back there. She come out here to visit, and mother got stuck on the country. The government had this open land here under the 'one section homestead act' [under which the homesteader could get one section of land by meeting certain qualifications]. The long and the short of it was, the government bet you a section of land against a $35 filing fee that you couldn't make a living on it for three years. At the end of three years, you could prove up on it if you wanted to. You had to have so much improvements on it—seems to me like $500 worth of improvements. Your house wasn't included in your improvements, but things like fence and wells and stock tanks, land broke out, things like that.

"Russell Lee was all over this country. He come out here and spent almost one whole day with us. Made all kinds of pictures. He had a 35-mm camera and he had a four-by-five, regular photographer's camera, one that he covered his head up with to get views with. I can say one thing for him—he was one hell of a good photographer, that man was. Russell and his wife was very, very likable people, very likable."

GEORGE HUTTON

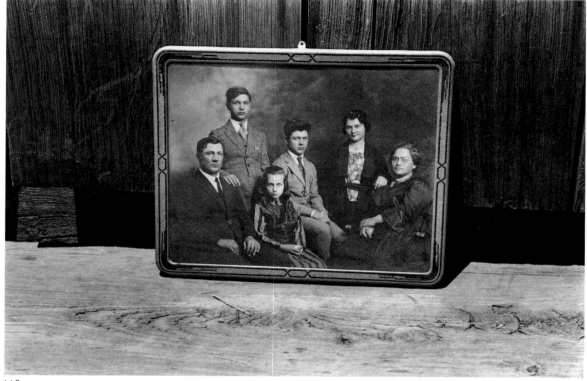
113

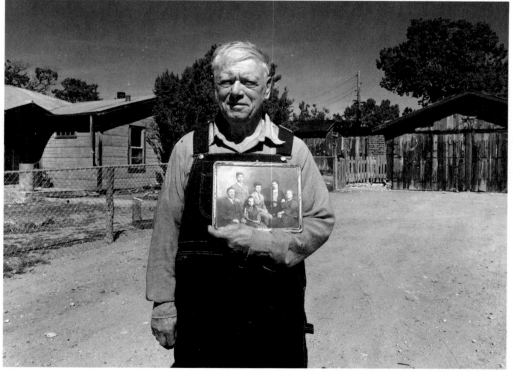
114

113
Picture of the Hutton
family taken about fifteen
years ago in Oklahoma
Pie Town, New Mexico
June 1940
Russell Lee

114
George Hutton on his
family's homestead
Pie Town, New Mexico
October 1980

115
George Hutton, Jr., in the
machine shop on his farm.
He does the work required
on his farm equipment and
also helps out his neighbors.
Pie Town, New Mexico
June 1940
Russell Lee

116
George Hutton in his
machine shop
Pie Town, New Mexico
October 1980

"I have done pretty well in supporting, keeping myself up. Work where you can and get all the money you can, build up here. Mr. Anderson over here at Pie Town—he runs the saw mill—he come out here one day, and he says, 'George,' he says, 'would you sell this machine shop?'

"I says, 'No way. Wayne,' I says, 'I spent forty-five years building up stuff so when I retired I could take life easy and do as I please. Work when I wanted to and fish when I want.' [Laughs.]

"Otherwise, life here has been on, you might say, a regular routine living. No outstanding incidents that's ever happened."

GEORGE HUTTON

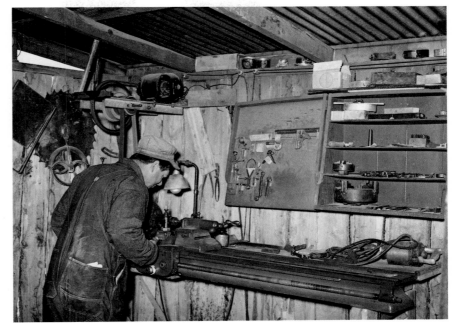

115

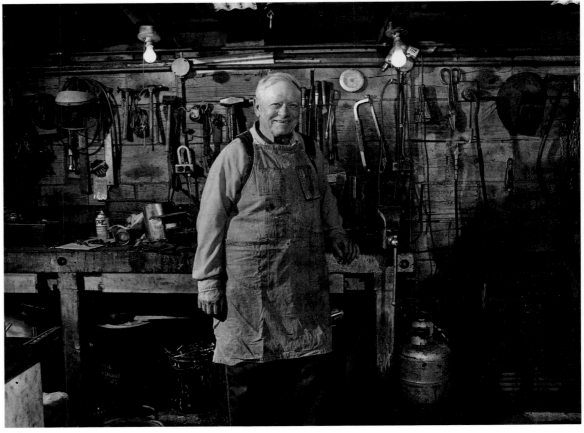

116

117
Jigger at the square dance
Pie Town, New Mexico
June 1940
Russell Lee

118
Dancers at a Democratic
party rally in Catlin County
(where Pie Town is located)
Reserve, New Mexico
October 1980

119
The men have a bottle of
beer at the square dance
Pie Town, New Mexico
June 1940
Russell Lee

120
The cooks for the Catlin
County Democratic party
rally
Reserve, New Mexico
October 1980

117

118

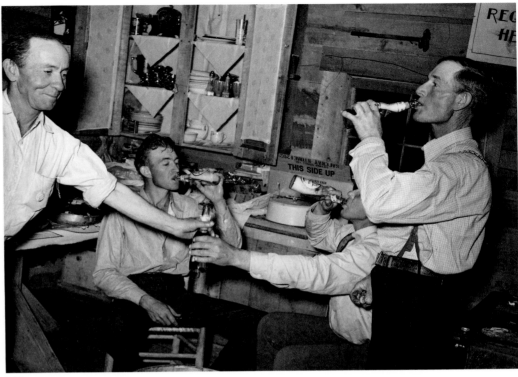

119

"There'd be dances on the average of every two weeks, there'd be a big dance somewhere over the country, within thirty miles of here. That's not true now. They had one over here in Pie Town Saturday night and that's the first dance they'd had in the country in six or eight months."

Did you go to the dances?

"Every one of 'em, and danced all night and then go down home and work all day! There was plenty of bootleggers in this country, too. There wasn't very little law and it was good money, ready money. Them old boys would go to these dances and they'd make quite a few dollars selling whiskey."

GEORGE HUTTON

120

"In North Platte, Nebraska, I met an ample forty-five-year-old blond lady who played the piano in a bar. Her name was Mildred, and she said she was a retired whore from Wichita. I told her I was a talent scout from Broadway, and her picture is in the file."

JOHN VACHON, photographer
in *Harper's,* September 1973

121

122

121
The Alamo Bar and Mildred
Irwin, entertainer
North Platte, Nebraska
October 1938
John Vachon

122
Saturday night at the Alamo
Bar with the owner (right),
his best friend, and the
waitress
North Platte, Nebraska
June 1978

123
Waitress and customers in
the Alamo Bar on a
Saturday night
North Platte, Nebraska
June 1978

124
Man and girl at the bar in a
saloon [the Alamo Bar]
North Platte, Nebraska
October 1938
John Vachon

123

124

125
Mildred Irwin, entertainer
North Platte, Nebraska
October 1938
John Vachon

126
J. C. Martinez and the
Western Swing Playboys,
Saturday night at the Alamo
Bar
North Platte, Nebraska
June 1978

"Hey, you gonna pick that song for me—'I'm the Only Hell My Mother Ever Raised'?"

PATRON OF THE ALAMO BAR during a break between songs

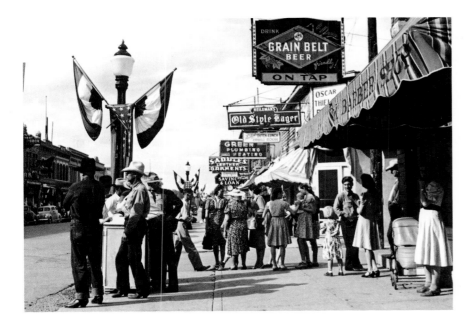

127
Main street
Sheridan, Wyoming
August 1941
Marion Post Wolcott

128
The Mint Bar on Main
Sheridan, Wyoming
October 1979

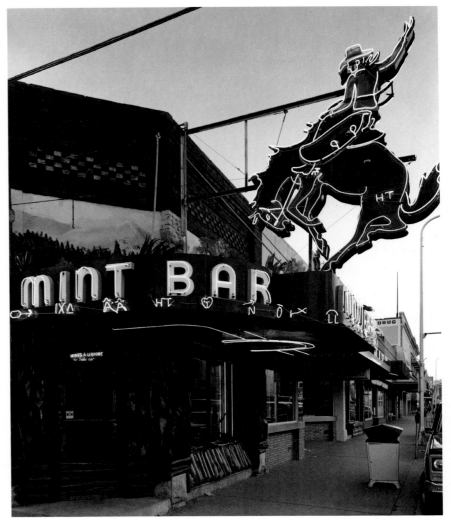

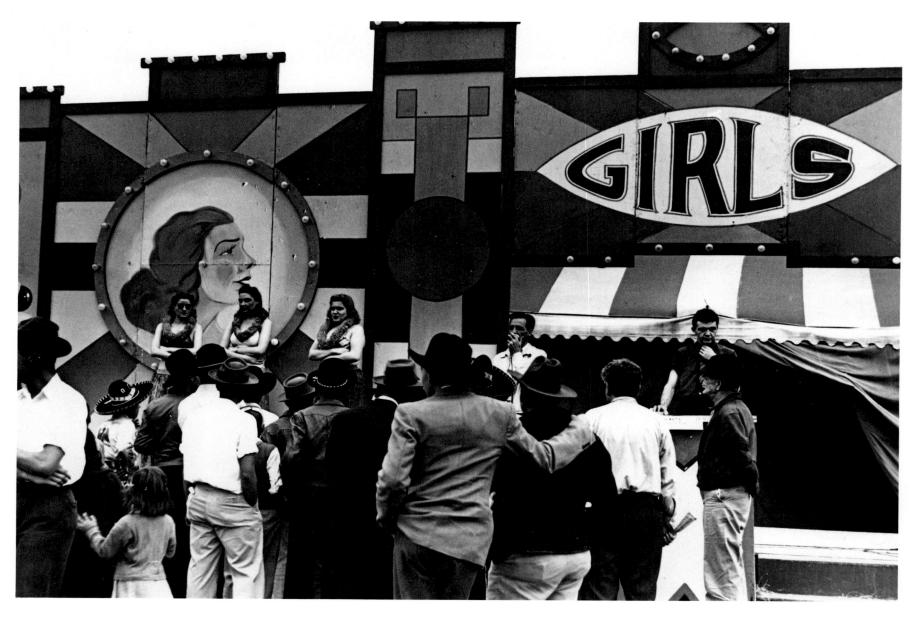

129
Girlie show at the carnival,
Charro Day Fiesta
Brownsville, Texas
February 1942
Arthur Rothstein

130
The pitch before the show
at the Club Vegas
burlesque, Nebraska State
Fair
Lincoln, Nebraska
September 1978

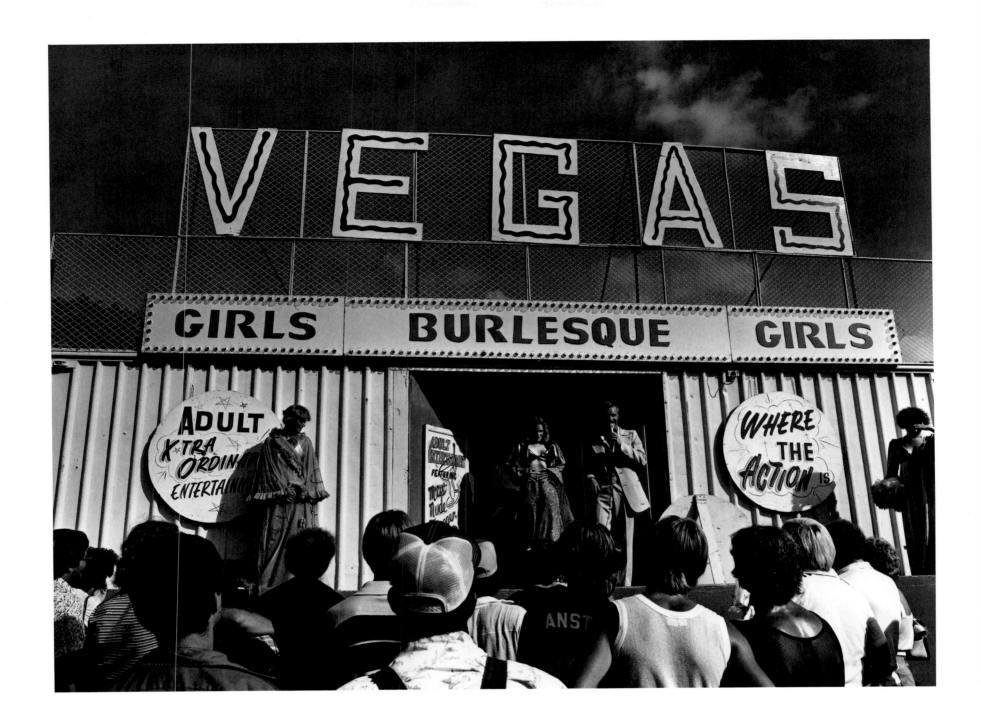

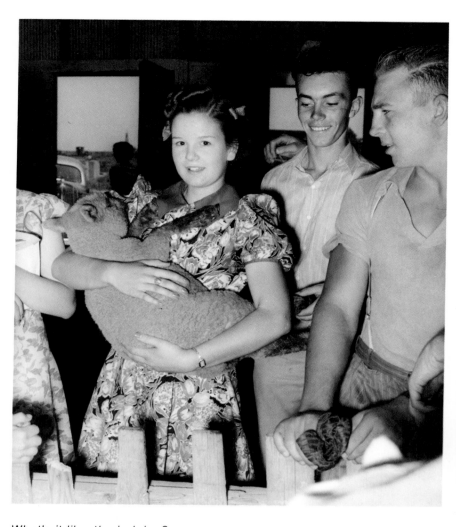

131
The 4-H fair; 4-H member
with lamb
Sublette, Kansas
September 1939
Russell Lee

132
Brian Waugh with grand
champion market lamb of
the 4-H county fair
Sublette, Kansas
August 1978

What's it like, the judging?

"Well, it's kind of scary. I just got really nervous,
and when he said that I won, I about let go of
my lamb. My lamb that won, I thought he was
the best lamb. But at the last, when I put my
hand behind his rear end, he kind of got away
from me. I had troubles.

"You want me to hold his head up?"

BRIAN WAUGH

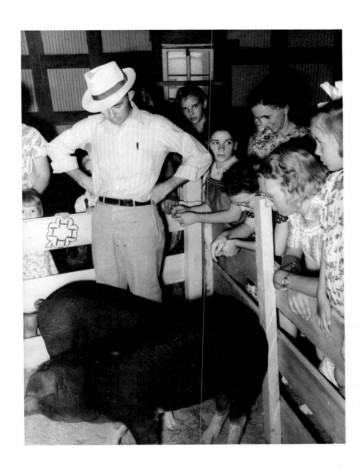

133
The 4-H fair, judging pigs,
with spectators looking on
Sublette, Kansas
September 1939
Russell Lee

134
Hog judging at the 4-H
county fair
Sublette, Kansas
August 1978

135
Paint ponies waiting for the
parade which will open the
San Angelo Fat Stock Show
San Angelo, Texas
March 1940
Russell Lee

136
Drill team performing a
countermarch during the
parade at the San Angelo
Stock Show and Rodeo
San Angelo, Texas
March 1979

137
Watching the parade which
opened the San Angelo Fat
Stock Show
San Angelo, Texas
March 1940
Russell Lee

138
Watching the parade
during rodeo week
San Angelo, Texas
March 1979

139

140

139
Terry Smith, Elaine
Burrows, Shelley Burrows,
and Lee Smith watching
the rodeo
San Angelo Stock Show
and Rodeo
March 1979

140
Rodeo clowns Miles Hare
and Tommy Lucia (inside
barrel) working a bull
San Angelo Stock Show
and Rodeo
March 1979

141
Spectators at a tense
moment during the rodeo
at the San Angelo Fat Stock
Show
San Angelo, Texas
March 1940
Russell Lee

141

142
Girls at the Junior Chamber
of Commerce dance during
the San Angelo Fat Stock
Show
San Angelo, Texas
March 1940
Russell Lee

143
Disco at the Santa Fe
Junction private club
during rodeo week. Special
dances are no longer
organized during the rodeo;
instead, all the motels
have discos that are
packed on weekends.
San Angelo, Texas
March 1979

142

143

144
Auctioneer at a sale of
steers and breeding stock
at the San Angelo Fat Stock
Show
San Angelo, Texas
March 1940
Russell Lee

145
Auctioneer at the sale of
champion stock at the San
Angelo Stock Show and
Rodeo
San Angelo, Texas
March 1979

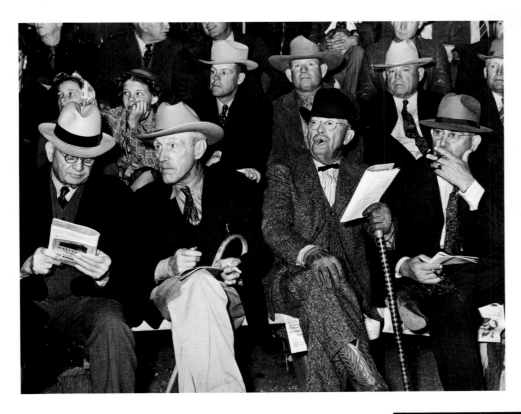

146
Cattlemen at auction of
prize steers and breeding
stock at the San Angelo Fat
Stock Show
San Angelo, Texas
March 1940
Russell Lee

147
Bidders and spectators at
the auction of champion
stock at the San Angelo
Stock Show and Rodeo
San Angelo, Texas
March 1979

148
Livestock commission
house [Tri City Auction
Company]
Grand Island, Nebraska
October 1938
John Vachon

149
The auction ring at the Tri
City Auction Company
Grand Island, Nebraska
June 1978

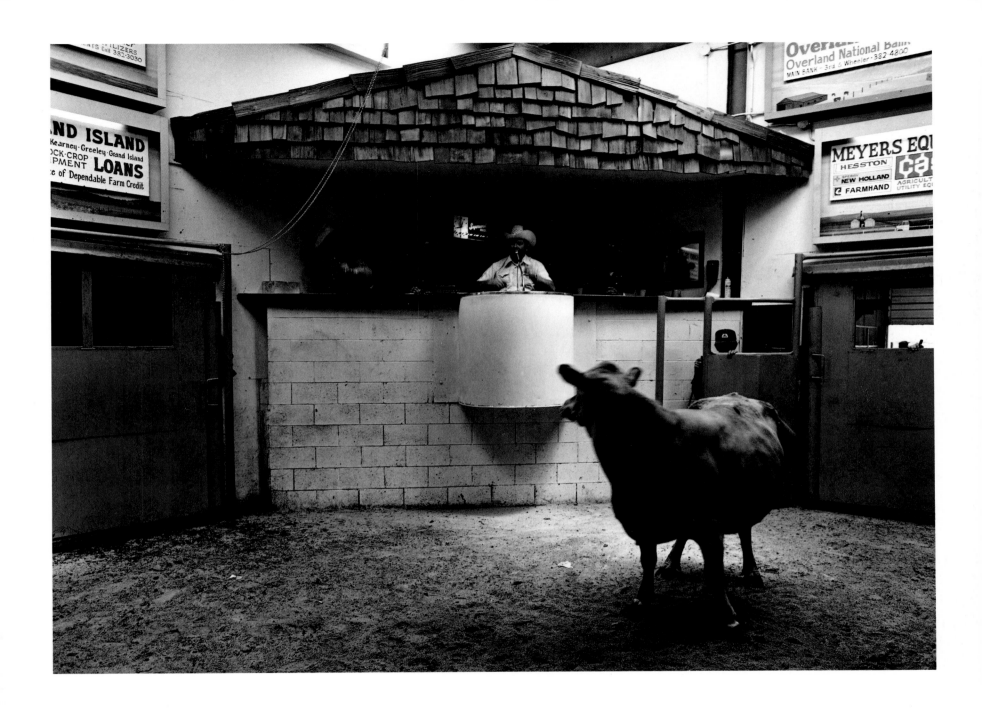

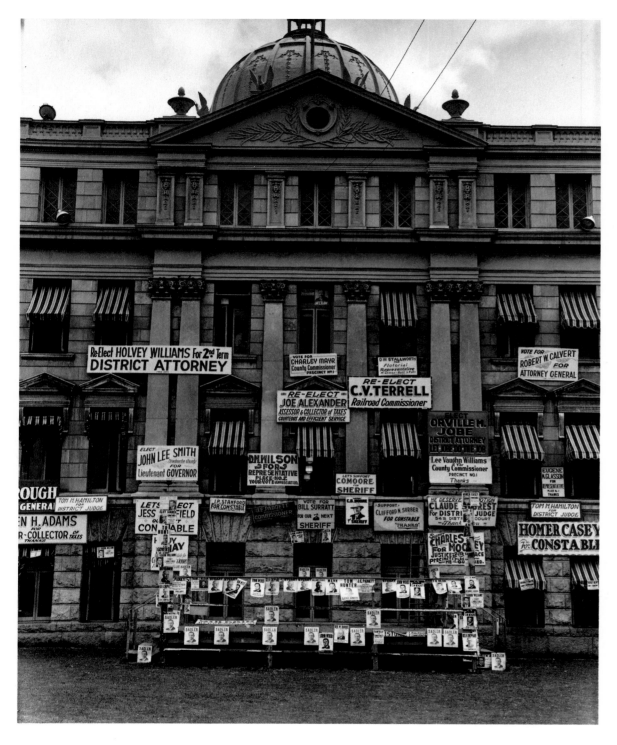

"Looks like I got a pretty good location for my sign there. This platform was here and the candidates were all up there. And this whole place was full of people, even out into the street and up the side streets. All the candidates would speak on one night. It took all night. All they did was get up and say who they were, what they were running for, what their qualifications were. Then they would get off.

"I was elected assessor first in 1936. And I held that office until I retired in 1972. My opponent in the '38 election, when he was in office, came up short about $55,000. My three predecessors all came up short. One time I was running and talking to this old boy down south, and he says, 'Joe, I'm going to vote for you, and you know why?' He says, 'I've known that office for fifty years and you're the first son of a bitch that hasn't stolen everything out of it.'"

JOE ALEXANDER

150
County courthouse just before primary election
Waco, Texas
1938
Dorothea Lange

151
Joe Alexander with his 1938 campaign poster, in front of the McLennan County Courthouse, during election week
Waco, Texas
November 1978

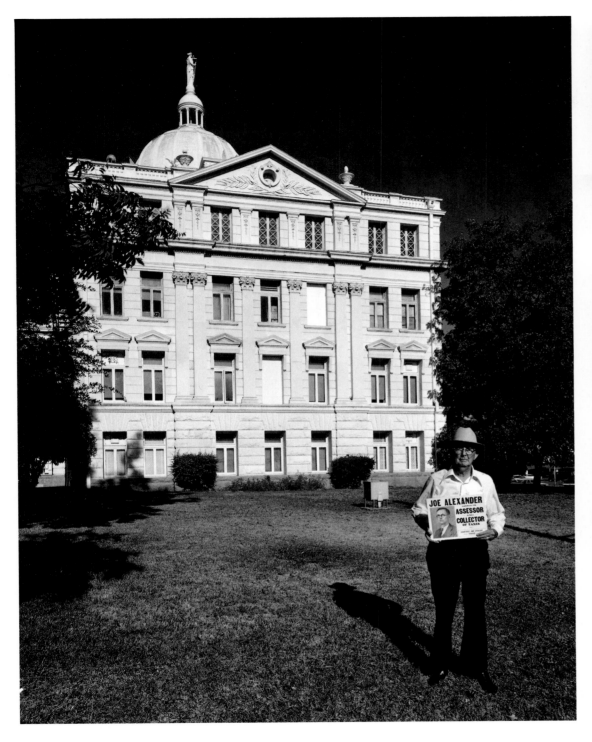

152
Leo R. Evans and Kent C.
Goul sitting and talking in
front of the courthouse
Columbus, Kansas
May 1979

153
County courthouse
Columbus, Kansas
May 1936
Arthur Rothstein

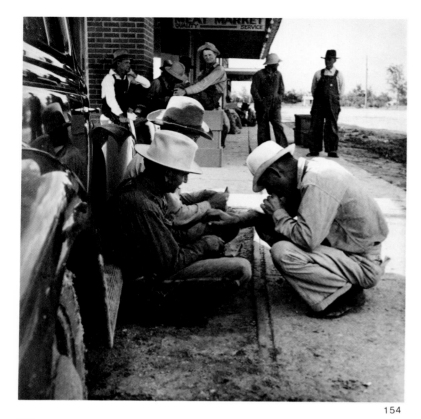

154

"Hello there, Bill. What do you know for certain?"

"Nothin'."

"Well, I know it's windy and dusty. It's got so we get half a day between the Spring Dust Storm and the Summer Dust Storm, and then we get a day and a half between the Summer Dusts and the Fall Dusts."

DOROTHEA LANGE AND PAUL S. TAYLOR
quoted by Dorothea Lange and Paul S. Taylor in
American Exodus

154
Dust bowl farmers of West
Texas in town
June 1937
Dorothea Lange

155
Walter Lynch, Marvin Little,
Orvil Hendman, and Velma
Lamb whittling, watching,
spitting, and jawing. "Just
sitting, trying to keep cool."
Ralls, Texas
August 1979

156
Town, abandoned because
of continuous crop failures
Keota, Colorado
October 1939
Arthur Rothstein

157
The Dean Bivens house (in
background), the last
inhabited dwelling
Keota, Colorado
October 1979

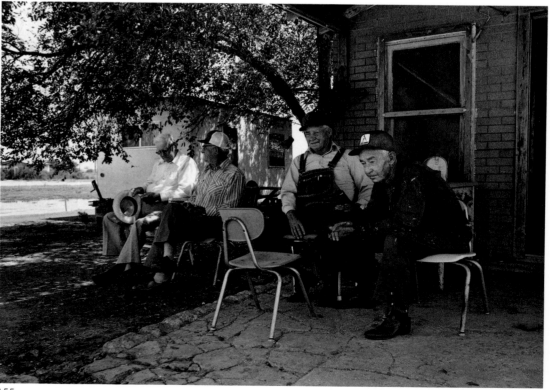

155

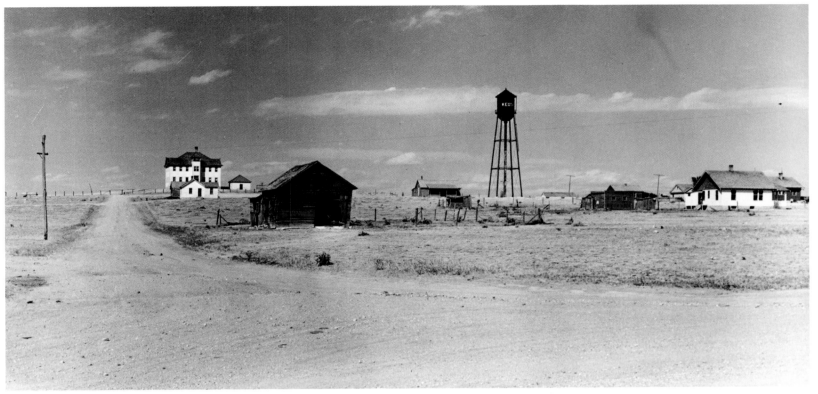

156

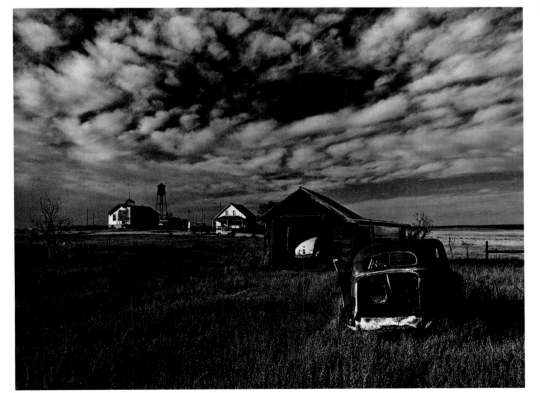

157

"Back in the early twenties, Keota was a thriving little town with a hotel, restaurant, butcher shop, two department stores, grocery, lumberyard, doctor, garage, post office, central telephone switchboard, water tower, and fire hydrants. There must have been two hundred people. But the final exodus began in the thirties with the terrific dust storms. I was standing here in the general store with Uncle Clyde [Stanley] the day the fire bell tower was blown to the ground by the wind. It was so noisy in the howling wind we couldn't talk. Today only two people live here."

AURIEL SANDSTEAD
(Sandstead's uncle, Clyde Stanley, introduced James Michener to the plains, and the book *Centennial* is dedicated to him.)

158
Sunset
Wall, South Dakota
May 1936
Arthur Rothstein

159
Wall, South Dakota
November 1979

160
Souvenir shop along
U.S. Highway 30
Kearney, Nebraska
May 1942
John Vachon

161
The Covered Wagon
souvenir shop, halfway
between Boston and
Frisco, 1,733 miles from
each city on U.S. 30
Kearney, Nebraska
June 1978

162
U.S. Highway 281
Aberdeen (vicinity),
South Dakota
February 1942
John Vachon

163
Billboard, U.S. Highway 30
Shelton (vicinity), Nebraska
April 1975

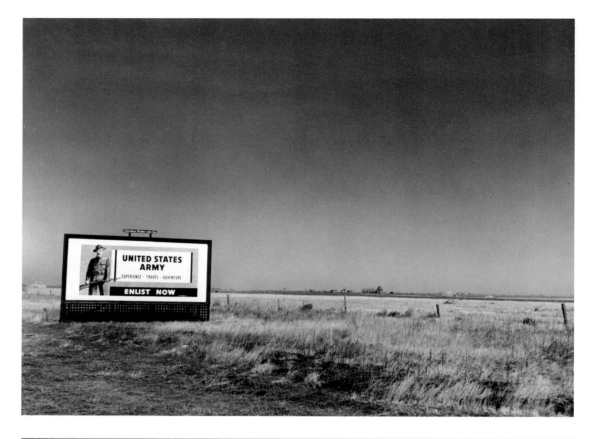

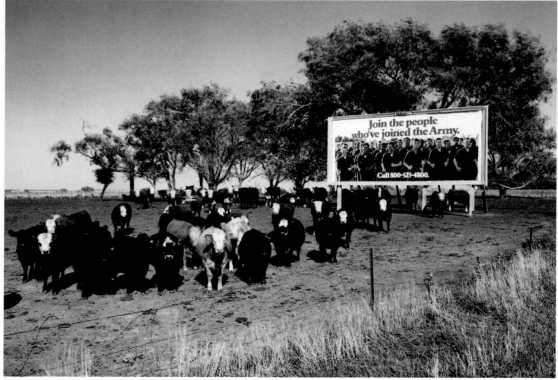

164
Odessa, Nebraska
November 1940
John Vachon

165
Along I-35
Three Sands, Oklahoma
March 1979

166
Folk art in Buffalo Bill's
home town
North Platte, Nebraska
October 1938
John Vachon

167
The Sioux Trading Post,
now abandoned
Ogallala, Nebraska
May 1976

168
The Phillips refinery
[Near] Borger, Texas
November 1942
John Vachon

169
Phillips 66 refinery
Phillips, Texas (just
outside of Borger)
October 1980

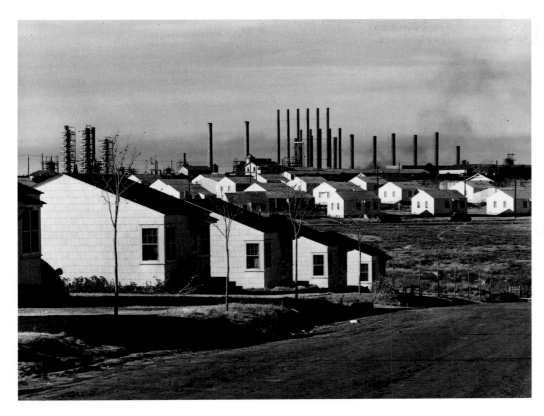

170
Workers' houses
and refinery
Phillips refinery
[Near] Borger, Texas
November 1942
John Vachon

171
Housing in the
company town
Phillips, Texas
October 1980

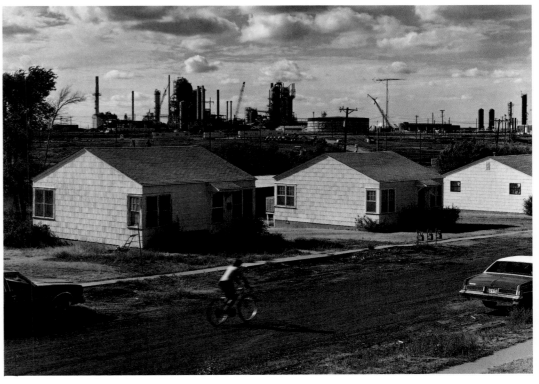

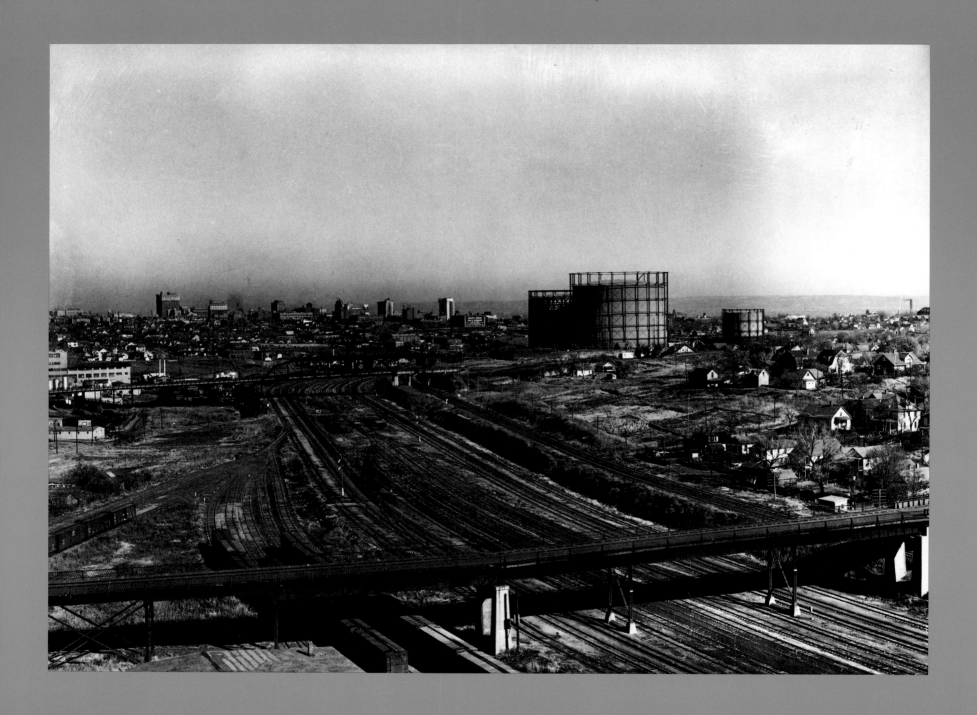

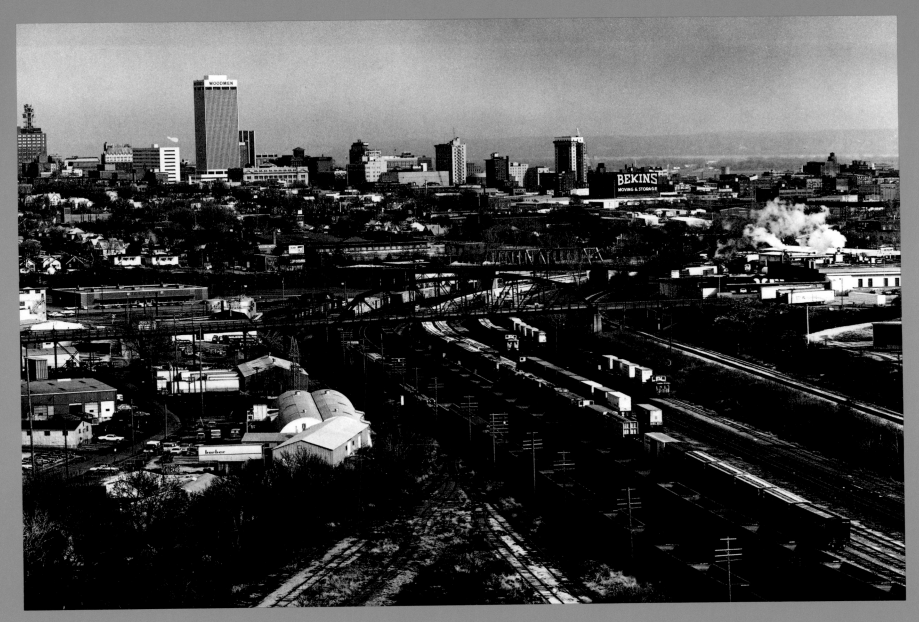

"This region is not the natural place for the development of large cities.... Kansas City is one of a ring of cities located just far enough [outside the plains and] within the Corn Belt to have an advantage of location as grain markets and for the meat-packing industry.

These cities, Kansas City, St. Joseph, Mo., Omaha, Neb., Sioux City, Iowa, have a hundred miles or so of corn-fields beyond them, so that range cattle can be fattened and never break their eastward movement from the range to the corn-field, to the packing-plant, to the Eastern market."

From, J. RUSSELL SMITH, *North America*

172
Omaha, Nebraska
November 1938
John Vachon

173
Omaha, Nebraska
May 1978

174
Lincoln, Nebraska
(State Capitol in back)
November 1940
John Vachon

175
Lincoln at night
June 1980

176
Ice cream parlor
Lincoln, Nebraska
October 1938
John Vachon

177
The Korn Popper, on
the site of the Iceberg
Lincoln, Nebraska
June 1978

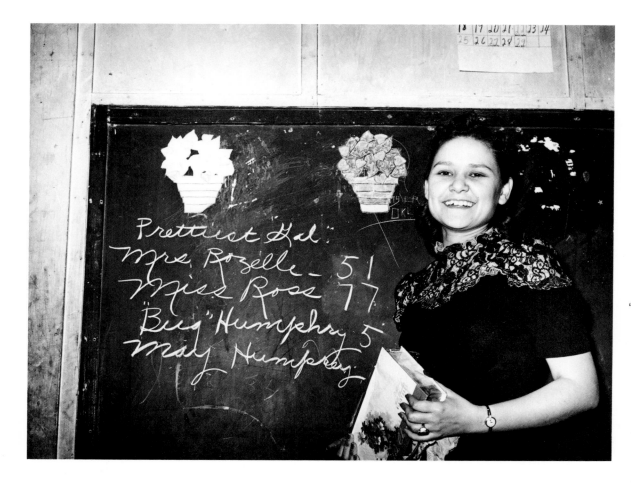

178
School teacher [May Ross] at rural school, winner of the prettiest girl contest at the pie supper
Muskogee County, Oklahoma
February 1940
Russell Lee

179
May (Ross) Lincoln at home
Oklahoma City, Oklahoma
May 1979

"The pie supper was a chance for everybody in the school and the rural neighborhood to get together. They were always well attended. There aren't too many opportunities for social gatherings like that out in the country. It would start about 7:00, during the spring. All the ladies brought pies and cakes. The young men and boys would play baseball. The girls would be over talking and chatting and giggling and laughing—wondering who was going to buy their pies. There was a lot of rivalry over who was going to get which pies. If it was obvious that there was a certain pie that a certain boy wanted, the rest would bid it up. One couple was engaged and they ran his pie up to $10. They made quite a bit of money.

"Then they had this contest for the 'prettiest girl.' I have a vague recollection of winning. I felt pleased about that, because I felt like the community approved of me. I really didn't think I was the prettiest, but it was kind of an honor.

"I taught for three years. Then I got married and moved to Oklahoma City, and I didn't ever teach any more."

MAY (ROSS) LINCOLN

"The Depression was a major factor in every-
body's life. Friends of mine who moved to
Omaha from farms were telling me that they
took a load of chickens in to the market and
were offered ten cents per chicken. They just
turned around—they'd rather eat 'em than sell
'em for ten cents. They decided to give up
farming and move to Omaha.

"So, it was difficult for my brother and sister and
I to go to college in 1938. We worked, of
course. I got a job as a bus boy and worked as
a waiter at the Theta house. That way I got my
meals. One big difference between us and
people in school now is that most now have a
pretty good feeling that when they get through,
there will be a demand for their services. That
was not at all true in the late thirties, early
forties. We knew we were going to go into the
service—that was clear even before the United
States was in the war. But when we got out,
what then?"

JOHN COCKLE

"I was pretty serious about studying, but there
isn't really a studying atmosphere here [at the
Reno, Nevada, high school]. This school is a
little more relaxed, it's not real competitive.
There's so much recreation to do. The weather's
always nice, and it's an affluent area. Everyone
I know has a car of their own. I'm going back to
the Midwest, to the University of Kansas, in the
fall."

MARY COCKLE

182
Bob Aden studying,
University of Nebraska
Lincoln, Nebraska
May 1942
John Vachon

183
Bob Aden working in his
back yard
Sioux Falls, South Dakota
July 1978

"Before the Depression, my father decided that he should buy some stock, and he bought it on margin. He might have mortgaged the family Model A in order to buy that damn stock. He bought General Motors at ten. He said General Motors couldn't possibly go down below ten. As I recall, it went down to eight. He finally paid it off, but it was pretty slim pickings around the dinner table. Later he lost his job in a merger. He scurried around and finally located a job here in Sioux Falls, selling on commission. He felt very fortunate to get it, but it must have been a hell of a job—just to go out in those days of Depression, to sell things on commission! But he kept us eating and had clothing on our backs. I was young, and as far as I was concerned it was a big adventure, moving to a new place, making new friends.

"I'm sure the experience of the Depression— what we went through—established patterns and habits that all of us have carried through for the rest of our lives. For example, I could never stand to buy anything on time; I had to have the money to pay for it. The first time I bought an appliance on time, it scared me to death. The only things I ever really went into deep debt for was my house and my business."

BOB ADEN

184
Southern California
architecture
Lawrence, Kansas
October 1938
John Vachon

185
Plastic franchise
architecture
Lawrence, Kansas
May 1979

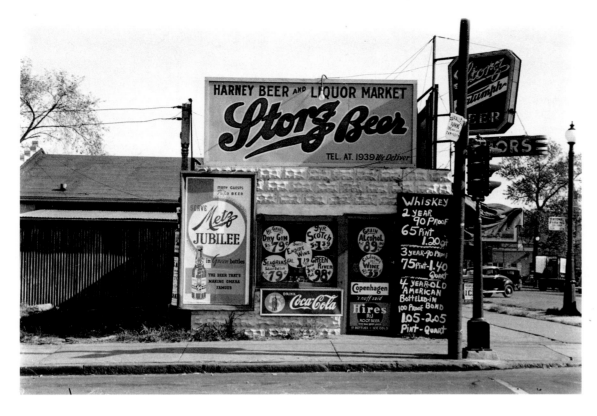

186
Liquor Store
Omaha, Nebraska
November 1938
John Vachon

187
Harney Beer and Liquor
Omaha, Nebraska
November 1977

"I had a boy that helped me load alfalfa seeds.
And when that noon whistle blew, he says, 'For
a man who's got money, that's eatin' time. But,'
he says, 'for the man who's broke, it's just
twelve o'clock.' "

WALTER BEAR, retired implement dealer

188
Farmers in town on
Saturday afternoon
[South 9th Street]
Lincoln, Nebraska
October 1938
John Vachon

189
Tony, Ray, and Larry
just after Saturday's
lunch at the City
Mission
South 9th Street,
Lincoln, Nebraska
January 1980

A TECHNICAL NOTE

The photographers of the FSA had a profound influence not only on our understanding of the Depression, but on the technical practice of photography as well. The FSA was one of the first major photographic projects in America to use the 35-mm camera extensively and seriously. It is not surprising that *Life* and *Look* quickly adopted the camera, since several FSA photographers went from that agency to the magazines. The FSA also pioneered in the use of flash for documentary photographs.

Typically, each FSA photographer might be outfitted with three cameras: a 35-mm range finder like the Leica, a medium format roll film camera such as the Super Ikonta B, and a press camera that shot either 3¼" x 4¼" or 4" x 5" negatives and was often used on a tripod as a view camera. Several photographers had their own cameras. Dorothea Lange often used a Rolleiflex, and Walker Evans used the massive 8" x 10" view camera. The photographer was supplied with film, chemicals, a $35-a-week salary, $5-a-day expense allowance, and 3¢-a-mile for travel. During the six to nine months that they were on the road, the photographers developed their film in hotel bathrooms and sent the negatives back to Washington. Prints were made and returned to the photographers for captions.

In my work, I have frankly borrowed some of the techniques of the FSA. As the project evolved, I became more and more impressed with the detail and tonal range of many of the photographs. So I traded in my 35-mm camera for larger format equipment. Roughly half of my photographs in this book were shot with a 4" x 5" Cambo view camera, the other half with what I consider my hand-held camera—a Pentax 6 x 7 (2¼" x 2¾" negatives). And though I didn't spend anywhere near nine months at a time on the road, I did travel close to 50,000 miles over the ten states of the plains during the ten years the project took. And I will imitate the FSA in another respect—I plan to donate the resulting photographs to a public repository, the Nebraska State Historical Society, to provide a record that can be used in the future in much the same way as I have used the FSA photographs.

All of the Farm Security Administration photographs in this book have been reproduced from the files of the Library of Congress. The following are the negative numbers for each FSA photograph. The plate number used in the book is given first, in bold type. Ordering information can be obtained from the Library of Congress, Photoduplication Service, Washington, DC, 20540.

1. LC-USF34-35827-D
3. LC-USZ62-47353
4. LC-USF342-8147-A
5. LC-USF34-2470-E
6. LC-USF342-8057-A
7. LC-USF34-8447-D
9. LC-USF34-4571-E
12. LC-USF34-61571-D
14. LC-USF34-18280-C
16. LC-USF34-2485-D
18. LC-USF34-4052-E
20. LC-USF34-4046-E
23. LC-USF34-17265-C
25. LC-USF34-5008-D
27. LC-USF34-5010-D
29. LC-USF34-20397
31. LC-USF34-9058-C
33. LC-USF34-18294-C
35. LC-USF34-18283-C
37. LC-USF34-18619-C
38. LC-USF34-20993-E
39. LC-USF34-16239-C
40. LC-USF34-21058-C
42. LC-USF34-28678-D
43. LC-USF34-28755-D
44. LC-USF34-28721-D
48. LC-USF34-15787-E
50. LC-USF34-15777-E
52. LC-USF34-4479-E
54. LC-USF34-4289-D
56. LC-USF34-5070-D
58. LC-USF33-11319-M1
60. LC-USF34-28372
62. LC-USF34-61552
64. LC-USF34-27617-D
66. LC-USF34-27507-D
68. LC-USF34-59386-D
71. LC-USF34-4274-D
73. LC-USF34-64715-D
75. LC-USF34-64805-D
77. LC-USF34-8665
79. LC-USF34-64946-D
81. LC-USF34-64985-D
83. LC-USF34-57901-D
85. LC-USF34-8906-D
87. LC-USF34-64633-D
89. LC-USF34-64614-D
91. LC-USF34-64764-D
93. LC-USF34-65792-D

95. LC-USF34-30486
97. LC-USF34-30438-D
99. LC-USF34-30813-D
100. LC-USF342-30864-A
102. LC-USF34-35806-D
104. LC-USF34-36796-D
105. LC-USF33-12748-M2
107. LC-USF34-36719-D
109. LC-USF34-36771-D
111. LC-USF34-36742-D
113. LC-USF33-12729-M4
115. LC-USF34-36736-D
117. LC-USF34-36912-C
119. LC-USF34-36898-D
121. LC-USF34-8761
124. LC-USF34-8772-D
125. LC-USF34-8753-D
127. LC-USF34-58737-E
129. LC-USF33-3693-M2
131. LC-USF34-34133-D
133. LC-USF34-34132-D
135. LC-USF33-12597-M4
137. LC-USF34-35464-D
141. LC-USF33-12589-M2
142. LC-USF34-35539-D
144. LC-USF34-35458-D
146. LC-USF34-35456-D
148. LC-USF33-1330-M2
150. LC-USF34-18261-C
153. LC-USF34-4225-E
154. LC-USF34-16961-E
156. LC-USF34-28367-D
158. LC-USF34-4658-E
160. LC-USF34-65738-D
162. LC-USF34-64665-D
164. LC-USF34-61825-D
166. LC-USF33-1329-M1
168. LC-USW3-11636-D
170. LC-USF34-11550-D
172. LC-USF34-8832-D
174. LC-USF34-61829
176. LC-USF33-1354-M4
178. LC-USF34-35274-D
180. LC-USW3-3018
182. LC-USW3-3079
184. LC-USF33-1273-M2
186. LC-USF33-1287-M4
188. LC-USF33-1259-M2